The Secret Vault

Frontier Publishing

Adventures Unlimited Press

The Secret Vault

The secret societies' manipulation of Saunière and the secret sanctuary of Notre-Dame-de-Marceille

Philip Coppens & André Douzet

Adventures Unlimited Press
Frontier Publishing

Frontier Publishing
Postbus 10681
1001 ER Amsterdam
the Netherlands
e-mail: fp@fsf.nl
http://www.frontierpublishing.nl

printed in China

Table of Contents

To the memory of Jos Bertaulet

Part I

Secret intrusions into the life of a village priest

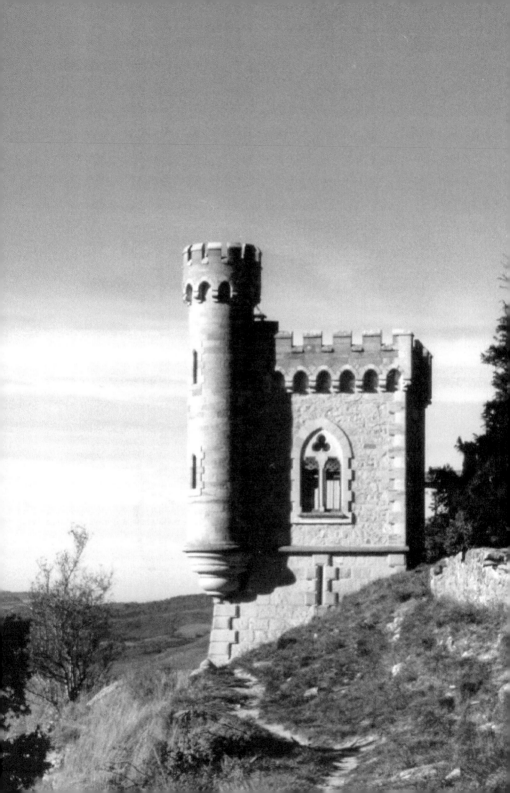

Chapter 1
The surprising means of a poor priest

Bérenger Saunière was a village priest, who somehow had access to wealth that he could not acquire by any visible means. How was that possible? Looking at the copious literature relating to the "problem" of Rennes-le-Château and its village priest, one can summarily classify some "observations" in the category of the ludicrous. The starting point is known: in general, all the authors admit that Saunière was the key figure in what would become, with the intervention of French journalist Gérard of Sède, the mystery of Rennes-le-Château.

Then, according to the overwhelming majority, it is agreed that this priest, a true pauper on his arrival in his parish, suddenly finds himself with a considerable capital at his disposal. Capital which quickly enables him to acquire goods first of all and in particular – later on – notoriety. The various works on the subject agree unanimously on the rapid but irregular ease with which the priest dispensed this wealth, firstly on essential repair work to the church of Rennes-le-Château, which was on the brink of collapsing. But he did not merely save the building from ruin, he specifically embellished and, at the very least, overloaded it somewhat with abundant decorations. There is so much "stuff" that volumes have been written on what exactly the interior was supposed to tell us. But at the time, nobody complained. The municipality was relieved financially of this expensive work, and the faithful congregation of this parish had an auspicious surrounding. Not even the religious authorities objected – at first.

But Saunière did not stop with refurbishments to his church. He was also generous towards certain laymen – some notable – and several of his colleagues. But in the end, it is true that there was no bigger recipient of his many generosities than the priest himself, thus demonstrating the popular proverb that true charity begins at home. First of all, the presbytery, the dwelling of the priest and of his staff, was suitably refitted. Then Saunière undertook the acquisition of the grounds surrounding the presbytery and the church, as far as the end of cliff – offering him stunning views over the surrounding landscape. On this property, he undertook a significant development: the construction of a comfortable dwelling, the Villa Bethania, followed by the "Tour Magdala" (to house his library). The grounds he had acquired were now in full use with a house, a tower, a garden and an annex with a conservatory and a greenhouse. To this day, they act as the magnet, which brings tourists to the village: to see the opulence in which our priest lived.

The adjacent cemetery would also benefit from Saunière's sums of money. As a result of this impressive cash flow, the centre of the village had been subjected to intensive restoration – and upgrades. A fine accomplishment by the village priest... it's just that no-one knows where the money came from.

All this is well known, and, in principle, is no major mystery. The story of the priest would still not have registered on the international top ten of mysteries were it not for the fact that his fortune would change.

Indeed: the death of Bishop Billard, benevolently disposed towards Saunière, marked the arrival of his successor, Mgr de Beauséjour. Both were Saunière's superiors, reigning their bishopric from Carcassonne. Both the tombs of Billard and de Beauséjour are inside the cathedral at Carcassonne, side by side, as if there was no difference between the two characters. But de Beauséjour was more "fastidious" and was specifically intrigued about the financial means of the priest of Rennes-le-Château, who came "with only one pair of shoes" but would depart with much more.

He demanded to see the accounts. A normal request, certainly, but Saunière was unwilling to obey. The exchange quickly intensified as the documents proving the priest's expenses were long in coming. The stormy situation finally degenerated into a show of force, which had a disastrous outcome for Bérenger Saunière. He was removed from his position as village priest, a removal which he refused to accept. Although the order meant he could no longer say mass inside the village church, he refused to move to his next posting. Furthermore, if he could not say mass in the church, he would say it elsewhere in the village – and the villagers followed him, it seems.

Until the end of his life, Saunière would defy the order and would continue to live in the Villa Bethania, which was, after all, his private estate, in the name of his maid, Marie Denarnaud.

All researchers agree on the above sequence of events – there are no disputes. It is only when the opinions on the financial origins of the priest's wealth enter into the debate that tempers flare. For some, the source was a sordid traffic in masses – people paying huge sums of money for the absolution of the sins of both the living and the deceased; the priest would intercede with God on the welfare of the soul. For others, it was the result of money received from archaeological discoveries made during the initial renovation work in his dilapidated church. Still others think it was the outcome of a lucky find, of a more or less inexhaustible treasure, although undoubtedly exhausted by the priest before his death.

Each one of these assumptions is at the same time both tangible and fragile. If one adheres to the version of the simple traffic of masses, the

act in itself is reprehensible, immoral, but by no means mysterious. Men of the cloth have often been tempted by the flesh, and by the smell of money. The consequences, and the sanctions envisaged remain within the framework of the Church. The discovery of a small nest-egg does not have either a diabolic or an illegal aspect. Admittedly, for such a fortuitous change in anyone's circumstances, it is preferable to observe certain administrative steps that reflect the change. But at the end of the 19th century, if the lucky party forgot to make such a declaration, there was no fear that any no legal consequences would be taken. The state was not yet out to make money from citizen's mistakes, definitely not when it came to the village priest.

If all this is summarised in a lamentable traffic of masses, we need to recognise that many details will remain as they are, without ever providing a satisfactory answer. However, the other solutions cannot be conceived without the complicity of a certain number of people and their interventions, done prudently from the shadows. And this might explain why Saunière was never willing or able to incriminate them, which would have happened if he had to account for his wealth.

It is impossible to repeat all the possible theories that exist on the subject. Instead, we need to focus on two key aspects of Saunière's life: his apparently fortunate relationship with his bishop, Mgr. Billard, and whether there are aspects of his known life that might shed light on the people who might have pulled his strings from the shadows.

As a base to start from, let us repeat those facts agreed upon by all parties:

· his arrival in Rennes-le-Château without any money;
· the lamentable state of the church and presbytery;
· a sudden and unexplained financial ease;
· his use of this unexpected fortune;
· the moment when the dream of Saunière turned into a nightmare;
· the desire of the priest not to justify himself in front of his superiors;
· his catastrophic exit.

Looking at this "fresco", it might be admitted that it could be simply a case of Saunière mixing with the "right people": rich friends, who wanted to help the priest in his endeavours to restore his parish. The modern day equivalent would be the billionaire who invests in a football team, because he wants to, not because he seeks a return on his investment. This means that there were people in Saunière's entourage who operated at a discreet level – but without any specific intent. This would explain some aspects of the enigma, but not all; specifically, why would Saunière refuse to name them, with such a catastrophic outcome to himself? Catastrophic in the sense that everything he had built, would be lost. It

would simply be too illogical. Furthermore, it does not explain the divide between the agreement of one bishop, and the disagreement of his successor.

Each of these processes is composed of several individual actions. For example, it is necessary to acquire a property, initially so that it exists administratively, then so that it belongs to somebody, then to have the financial means to buy it, accompanied by a lawful deed legalising the transaction. It is the same process for the construction of a building, or the restoration of one. It would be quite hazardous to consider these blocks of activity to be generated by a sphere of activity of occult forces or of Saunière being handled by an unspecified esoteric group. Furthermore, one's financial ease, however sudden, is in itself neither prohibited nor a punishable act insofar as it rises from elements that can be explained and that are legal. Therefore, his commitment not to reveal his sources leans towards a conclusion that he simply could not divulge names.

The anomalous source of his income does not start from his earliest arrival in the village. There is traceable evidence from those early days that shows he was a man without money. However, various testimonies confirm that Saunière did make a discovery early on:

· a small flask found in the balustrade of the pulpit of his church;
· perhaps a small nest egg discovered when dealing with a flagstone or a small pillar in the choir of the church;
· perhaps several small deposits near the pulpit.

The small flask left in the balustrade could have contained only a negligible religious relic or a very small piece of manuscript. As to the "nest egg", discovered fortuitously during masonry work, if it were not completely negligible, it does not seem to be a very substantial treasure... Moreover, Saunière's life style did not change radically as a consequence of these discoveries and he was still in financial difficulties while continuing with the essential work in his church.

Right up until now, we are still in the realm of a poor village priest who, during essential work in his church, finds a small deposit that, at most, enables him to continue the larger repairs with less difficulty than beforehand. No need to resort to a fabulous treasure, or claim outside interventions. But it could very well be that these discoveries paved the way for the arrival of shadowy figures. After all, it is at this point in time that most opinions about Saunière begin to diverge – and speculation arises as to what happened next.

The life of Berenger Saunière was to be that of an ordinary priest. It was destined to be; perhaps he had no other ambitions. Only one person

could ever be pope at any one time and most priests knew that they would minister to communities often quite close to where they had been born. For some, a career was carved out, sometimes as the result of seniority, but for the higher positions, more the result of family connections – or of noble birth. Saunière seems to have had neither, as it is clear that he always remained village priest – until even that was no longer condoned by his superior. He never climbed a career ladder and in the end he even fell from the lowest step.

When he entered the parish of Rennes-le-Château, the village had already seen a very long succession of priests since the foundation of the place of worship there – which, most believe, took place in the 11th century. If each new village priest of Rennes-le-Château had potentially the same destiny as that of Saunière, we would have testimony to their fortune... and it would make the village the most desired posting in the Razès! However, this was obviously not the case. Many priests serving in Rennes-le-Château seem to have lived there modestly, apparently not even possessing the means for essential maintenance of the church and presbytery. His immediate predecessor experienced the same state of accommodation and would surely have changed them for the better if he could have done so.

Yet, here, in the final decade of the 19th century, Rennes-le-Château, through its priest, suddenly departs from its destined anonymity; and it seems obvious that all of this could only occur through some external intervention. Who in the village had the financial means to support Saunière, not only for the restoration of his church, but also of his personal welfare? If the money was of a local origin, then surely the benefactor would also invest it himself, in his own house? But it is known that nothing else in Rennes-le-Château grew at the same time and at the same pace as the wealth of the priest – suggesting the source was known to the priest, but not to the village.

So it seems that his initial discoveries inside the church transformed his destiny. We know something was discovered; there are eyewitness accounts whose credibility has never been in doubt. We know that at one point, when workmen came upon a find, they were sent home for some days before Saunière allowed them continue their work.

It seems logical to assume that initially, the discovery was thought to be of little value. He might have contacted other amateur archaeologists to estimate the possible value of the finds. They might then have made further enquiries with more knowledgeable experts – often further away. Experts which Saunière himself initially would probably not know personally; he was after all a village priest in a remote area.

If the discovered item was of any value, these experts might have offered to buy it at a certain price. Alternatively, his first point of contact might

9

have asked Saunière whether he wanted him to try and sell it on behalf of the priest. In both possibilities, Saunière must have wondered whether the offer was right; and if a substantial sum was offered, Saunière must have wondered why people were willing to pay a high price for it. If the sum was exceedingly high, it might even have caused suspicions to be aroused. Perhaps Saunière thought he should try and get even more. There is an alternative route: that is that Saunière decided to become a player himself. At the most basic level, Saunière could have sold the item, without ever coming back to it. A one-off transaction. Alternatively, Saunière might have decided to become a player himself: he might have decided not to sell it, and instead engage directly with the people willing to part with huge sums of money for his prized possession. Or he might have decided to sell it, and consequently decide to investigate why his buyers were willing to buy it – a private quest, after the events.

If Saunière did have a prized possession, then the private sale would mean the transaction was illegal – and open to successive penal proceedings. If he decided to mix with the potential buyers, then it could be potentially dangerous: if Saunière was unwilling to sell, and the buyers wanted it desperately, perhaps they would not think twice about putting some "harm" in Saunière's way. However, it is clear that this did not occur – if anything, Saunière remained untouchable, until the bishop's mitre changed heads much later on.

In the theoretical scenario that Saunière would put his finds on offer, it is clear that he had to do these transactions through an intermediary. The priest had no means of transport of his own. And it is clear that any potential buyer would live in more urban areas, if not the metropolis of a city like Lyons or Paris – a long distance away from the rural Rennes-le-Château for a man with no means. So if Saunière used an intermediary, it is clear that this person would prefer to see a commission for his interventions.

The intermittent selling of "something" that Saunière had in his possession would explain the stop-go approach to many of his projects: it seems that he had waves of inexplicable income, but also certain periods when nothing entered his purse. Alternatively, it might be that Saunière wanted to have big breaks between the various building projects that he undertook in the village; perhaps in an unsuccessful effort not to raise suspicion, or for other, personal reasons.

This theoretical scenario could explain all Saunière's strange meanderings. It could explain why at some point in time, his superior became suspicious and opened an official enquiry. We could subscribe to this satisfactory scenario, and turn the page. However, there remains another possibility that should not be neglected.

Chapter 2
Two lives for one priest

Let us join Saunière once again at the time when he is making some urgent repairs to his church. What did he find? The consensus of the body of researchers into the mystery is that these were two parchments, displaying biblical texts. We strongly disagree with this and have made our objections known in earlier publications. In short, the people who leaked these parchments and claimed they were the source of Saunière's wealth later admitted, in an official police investigation, that they themselves had fabricated these documents. No doubt in an effort to save some face, they added that although fakes, they had, nevertheless, been copied from an "original document", which no-one has ever seen – and if ever in existence, was not in the possession of the fakers. To put names to these people: the group of fakers were Pierre Plantard and Philippe de Chérisey; the believers are many, but specifically Gérard de Sède and Michael Baigent, Richard Leigh and Henry Lincoln.
With this knowledge – which many researchers fail to accept as the harsh reality – is there anything else to hold on to that could explain the source of Saunière's wealth? There is. There are the personal notes of the priest, which mention the discovery of a tomb. This short, one-line statement, however, lacks detail – and future entries do not shed any further light either.
The mention of this discovery of a tomb is known to all researchers. It is a statement in a line of known events. Similar entries from his personal notes have been used to flesh out the life of Saunière. But, unfortunately, to sceptics, the notes have become the backbone of his life – to which no exceptions can be made. The notes are believed to reflect his life and his whole life – no grey zones are allowed; we know "everything" about Saunière – even though "everything" does not explain "everything", i. e. the enigma of his wealth.
The logical conclusion therefore has to be that certain episodes from Saunière's life were not noted down in his notes. For example, the notes list the various invoices, orders, various mails, columns of meticulous accountancy. They would therefore be of great help to reconstruct his road to wealth when asked for it by his bishop. But this is where his notes let both Saunière and us down. There is almost nothing there concerning the various building projects he embarked upon. If Saunière did carefully manage his building projects, it is clear he recorded it in another document – not in these notes. Proof therefore that the notes definitely do not contain the total of Saunière's life.

So back to the enigmatic entry, for 21st September, 1891: "Letter from Granes. Discovered a tomb, rain in the evening." The entry is enigmatic for the following reason: he mentions it rained that day, even that it rained in the evening – as opposed to a morning or lunch-time shower. That he received a letter, from Granes. But when it comes to the tomb: where did he discover it? When? In the morning? How did he discover it? Whose tomb was it? No mention at all is made of details that should be deemed to be of more interest than whether or not it rained that day. It is just one of several anomalies in Saunière's note: there is no mention of the discovery in the pulpit, even though we have eyewitness testimony that the discoveries were made. But Saunière did not report them in these notes.

It is therefore clear that Saunière had a paradoxical approach. The notes we have go into anal details about mundane aspects of his personal life – so much so that normal people might wonder whether Saunière was slightly autistic, noting down unimportant events. But major events were never noted down: nothing about the discovery in his pulpit, nothing about his building projects. That is the paradox: anal detail on the mundane versus complete absence of interesting events.

As Saunière seems to have been a careful administrator, it would suggest that there was a second notebook, reserved for notes of a more confidential nature. But if it did exist, it is clear that it is not in the public domain. Either it was lost, or is kept close by someone, who happened to acquire it. Whatever the correct answer, it is clear that no-one can continue to conclude logically that the notebook we have at our disposal contains the total of his life.

However, another conclusion needs to be drawn from this evidence. As the discovery of the find in the church was not noted down in the notebook, it is clear that Saunière did not see it as a mundane discovery. Otherwise, we would have expected a one-liner, along the lines of "workmen discovered small phial in pulpit". It would prove that the discovery was of no consequence to Saunière and would probably not receive a follow-up.

Let us erect some scaffolding around this acceptable assumption: that Bérenger Saunière practised double book-keeping: one for the mundane aspects of his life, one for his secret life – or perhaps to phrase it more correctly: that part of his life which he could not answer for. If that is the case, then it is clear that to all intents and purposes, Saunière led a double life. Although it might seem a perfect ploy, it has a major flaw: because Saunière decided not to include any details of his building projects in his "mundane folder", they lead to the suspicion that there is a missing notebook. At the same time, it is clear that if the "notebook of mundane affaires" is found, most would be put off the trail of looking for more

notebooks. Only detailed analysis of the "mundane notebook" would eventually lead to the conclusion that something was missing. And, as mentioned before, there is the possibility that Saunière simply did not take notes about the details of his building projects – however unlikely that may be.

It is also clear that if de Beauséjour had never opened a public investigation into Saunière's activities and had not requested his accounts, Saunière would probably have got away with his stunt. Everyone would have accepted his "mundane notebook" as all there was – or would simply never have become interested in the man at all. How was Saunière to know that almost twenty years later, he would stumble upon a superior, who did not share his passion – or to phrase it differently - does not seem to have been a member of the same "circle" to which Saunière belonged - and to which it seems Billard belonged as well?

We are left with two lives. The first life is that of Saunière, the village priest, living amongst his parishioners, herding his parishioners towards God. The second life was born in his first, but grew bigger the older he became. It began when he made a discovery in his church, and grew when he shared it with others, perhaps at first, neighbouring village priests. If that was the sequence of events, then his colleagues would be vital keys in his ensuing life. They were close to the source; they would see Saunière's lifestyle and might want to partake of it themselves. Furthermore, they would have seen Saunière change: from a man who did not know what it was what he had found, to a man who defied his superiors.

Although some might have penetrated Saunière's firewall, it is clear that only one person was allowed to share his inner sanctum: his maid, Marie Dénarnaud. Probably more by accident than design, she became his confidant, perhaps his sounding board to test his ideas or projects. It is clear that he had to confide in her, for she was always there. If she was not on board, she could have become an enemy and a stumbling block. It is clear that there never were any problems. He used her to buy the estates in her name, so that they would remain out of reach of the Church; at the same time, they would provide for her future benefit, if ever something befell him. And we know this is the case because after Saunière's death in 1917, she continued to live in the estate, until she had to sell it – the money had dried up. It suggests that even though Saunière had "extra income", it was not an unfathomable source of money out of which Marie could continue to dig. It suggests that the extra income ended when Saunière died and that Marie continued to live happily for a long time after – but not forever after. And it is clear that the pot of honey available to Saunière, was not available to his successor.

It is also clear that Marie herself felt she could not divulge Saunière's

secret after his death. Late in life, she promised to divulge it to Noel Corbu, who had bought the estate from her and who allowed Marie to live there for the rest of her life. Thirty years after Saunière's death, it seems that Marie felt it would be safe to divulge the source of his income to at least one person. Unfortunately, she suffered a stroke, which prevented her from sharing it. It seems to underline the possibility that by that time, Saunière's secret could be divulged safely, which, it seems, it was not safe to do so at the moment of his death or in the immediate aftermath. Perhaps it might be self-preservation. Perhaps she thought that if she divulged his secret, she might loose the estates and would be homeless. Or perhaps his "handlers" were still alive and present around 1917, but were no longer interested in Marie or Saunière three decades later.

Still, it is clear that Saunière himself never disclosed his secret and by common consent, neither did Marie. This means that to all intents and purposes, his secret life remained firmly closed – and thus the enigma of Rennes-le-Château was born.

But we have travelled too far in time. We need to return to the early days of his "second life". Although I happened to chance upon evidence that proved that Saunière led such a life, I would not argue that I found the "master key". Still, they were intriguing pieces of a puzzle.

The first clearly defined set of pieces was the discovery that Saunière had spent time in Lyons, a major metropolis several hundred kilometres away from his hometown. When I made this knowledge public, people zoomed in on one aspect: that Saunière had attended meetings of a Martinist lodge in that city. Martinism was a movement, specifically for priests, which promoted the concept of the "Inner Way": rather than have the Church intercede with God on a person's behalf, the Inner Way was that direct experience of the divine, and growth towards God – or Heaven – lay within the potential of every individual.

Those researchers unwilling to accept this new dimension to Saunière's life stated that it was illogical to assume that our village priest would – or could – make the trip from Rennes-le-Château to Lyons specifically to attend this meeting. That is definitely true – but alas for them, it is never what I argued. The evidence showed that in essence, Saunière lived in Lyons for periods of time, renting a house, renting a carriage. When he was in Lyons, he attended a Martinist meeting as a guest. He was never a member; someone he knew in Lyons had obviously invited him to "come along". Martinism targeted priests specifically and therefore Saunière would have been a logical "target". As Saunière was at best an infrequent resident, it is also clear he would never be able to attend the frequent meetings of the lodge – and hence it is why the evidence shows that he attended once or twice, as a guest, but never as a member.

What this evidence showed, therefore, was that for whatever reason, Saunière spent time in Lyons, and that while there, he often reserved a means of transportation. This meant that somehow, he had to go about in search of whatever – or alternatively had time to spare and wanted to see the countryside. What he did is not of primary importance (and has been detailed in an earlier publication). What is important is that it was evidence of his double life. The Lyons period, it should be said, occurred around 1897 – some six years after the initial discovery – and still several years before his superior would begin to make life difficult for him.

That was not all. It is also clear that Saunière went elsewhere, specifically to Durban-Corbières. There, he went to have "good meals" and speak to local scholars. Durban-Corbières might seem a long way from Rennes-le-Château and to some extent it is. But then in his "mundane life", Saunière would obviously be allowed to have occasional days off and have some friends elsewhere. It seems that he definitely had those in that region, not too distant from Rennes-le-Château.

Nevertheless, it seems that these visits were not part of his mundane life either. For one thing, it is known that he had bank accounts in Perpignan, near Durban-Corbières. Also, it seems that at some point in time de Beauséjour must have known about Saunière's visit to the region – or else it was a major coincidence. After having told Saunière to leave the parish of Saunière, he offered Saunière a parish near Durban-Corbieres. Saunière refused. It is clear that Saunière refused to leave his private estates behind. But perhaps it might also be that Saunière did not want to move to the area of Durban-Corbières, because of his previous visits there. The only thing we know with any certainty, is that he officially declined the posting, saying the parish was too close to a Charterhouse – which definitely was an excuse, as no such Charterhouse existed in that area. The episode is intriguing, for it proves that, in his attempts to oppose his superior, Saunière could resort to lies, which his superior would easily identify as lies.

Jean-Luc Chaumeil notes that Saunière's absences from home were numerous and often lasted one week. "We know that he went to Perpignan, where he stayed in the hotel Eugène Castel, and that he took the greatest precautions so that people would believe he had not left his parish, specifically by sending letters to his superiors which he had written before his departure and which his servant, during his absence, posted in the village of Couiza."

But let us return once again closer to home, and even closer to 1891, when the "weirdness" in his life began to increase rapidly. Henri Boudet was the village priest of neighbouring Rennes-les-Bains. Although there were villages closer to Saunière (Couiza down the hill being an obvious example), it seems that Boudet was a prime candidate to become

15

Saunière's first point of contact when it came to enigmatic affairs.

First of all, Henri Boudet was the author of an enigmatic book, which he had published privately: La Vraie Langue Celtique et le Cromleck de Rennes-les-Bains. It stated that the language of the ancient Celts was none other than modern English. Bizarre, or rather eccentric, but innocent enough. Some might see it as a scheme to make a quick buck, but it seems that Boudet was generally interested in history and archaeology. He was a member of the Société des Arts et des Sciences de Carcassonne, with its headquarters at Carcassonne, the town from where Billard, both his and Saunière's superior, ruled. He presented it to the association on 5th November, 1893 and 3rd November, 1896. Boudet also contributed material to the Société des Etudes Scientifiques d'Aude until the end of the 19th century.

As Roger Facon has stated, Boudet might have tried to emulate Jonathan Swift (1667-1754), who in Gulliver's Travels, stated that Hebrew, Greek and Latin were all descended from English. It seems that Boudet wanted to add Celtic to that list.

The "quick buck" definitely never materialised either. Boudet paid for the costs himself, 5382 gold francs in total. In the period 1886-1914, only 98 copies were ever sold; an additional hundred were sent to libraries, and 200 copies were given to interested visitors to the town. Even the English Queen Victoria was given a copy. The remaining 102 copies were destroyed in 1914, the year before his death – and the year Boudet also was removed from his office as village priest by de Beauséjour. There was no mystery to this removal. Boudet had been diagnosed with cancer of the intestines; at the age of 77, it was clear his days were almost numbered. Nevertheless, in 1915, he left his retirement home in Axat, to go to Rennes-le-Château, to die in Saunière's arms on 30th March, 1915, underlining the two priests' close relationship.

It is clear that if Saunière had ever made an archaeological discovery, Boudet would be an obvious first point of contact – and there was the added bonus that Boudet was a colleague as well. Furthermore, it is clear that because of his previous track record, whatever claim Boudet would make public, few would believe him.

Let us recap: we now have proof that Saunière led a double life. We have identified Boudet as a likely point of first contact if he wanted to sell or know the value of an archaeological discovery in his possession. It seems clear that Saunière never "just" sold it; he maintained an active interest in "something" and would lead a double life that involved secret bank accounts in Perpignan and even in the Hungarian capital of Budapest, secret long-term trips to Lyons and shorter "day trips" to Durban-Corbières. We know that his maid, Marie Denarnaud, was his most trusted confidant.

Where do we go from here?
It is clear that we need to probe around in his mundane life, to see whether it will take us into his secret life. It is a universe into which we need to venture prudently. Let us therefore use known dates and facts about Saunière as a guide.

April 11, 1852	Birth at Montazel of Bérenger Saunière.
1879	Is ordained priest and becomes vicar of Alet-les-Bains.
1882 - 1885	Priest at the village of Clat.
June 1, 1885	Saunière arrives at Rennes-le-Château. The presbytery is uninhabitable and the church close to ruin.
1886, January	At the seminary in Narbonne after his suspension because of his anti-republican sermon in October 1885.
1886, July 1	Return to Rennes with a gift of 3000 francs from the countess de Chambord.
1886 – 1891	Starts renovations.
1886 – 1887	Several fortuitous discoveries are made during these repairs
1886	Gift to de Grassaud, priest, of an old chalice
1887	Purchase of the stained glass windows dedicated to Mary Magdalene.
1888, 1889, 1890	Discovery of the "stone of the knights" (Dalle des chevaliers), the hiding place in the balustrade and perhaps other similar finds
1890	Commencement of the restorations to the presbytery and the cemetery.
1891, June 21	Installation of a statue of the Virgin Mary on a Visigothic pillar, placed upside down, with the engraving of the words "Penitence! Penitence!" and "Mission 1891".
1891	notes in his diary: · delivery and installation of a new pulpit (Giscard House, Toulouse). · affixing to the porch of the church the heraldic blazons of Mgr Billard and those of Pope Leo XIII.
1891, September 21	"Letter from Granes. Discovered of a tomb, rain in the evening."
1891	Saunière starts to keep detailed accounts of the masses he is asked to say – which is above board.
1892	Work on the presbytery, the cemetery and its access, etc.
1892	Marie Dénarnaud remains in residence with her family

	in the presbytery.
1894	Restoration of the cemetery and area around the church.
1895	The work in the cemetery irritates the village inhabitants. Two petitions (dated March 12 and 14) are addressed to the Prefect to put an end to these acts.
1896	According to Corbu, if there ever was trafficking of masses, it had to begin this year.
1897	A large fresco is delivered and installed on top of the confessional.
1898	Further work in upgrading all areas of the church and immediate surroundings.
1898	Begins with the acquisition of the grounds for his domain.
1898, May, June and September.	Saunière is in Lyons.
1898 – 1905	Purchase of the grounds for his Villa Bethania; seven parcels of property are registered.
1899, July.	Another stay in Lyons.
1900, May.	Last known voyage to Lyons.
1901	Commencement of work at the Villa Bethania.
1905	Completion of work at the Villa Bethania.
1906 – 1907	Reciprocal wills of Marie Dénarnaud and Saunière.
1907 – 1908	Troublesome years for Berenger Saunière.
1909	Significant financial difficulties.
1910 – 1911	Lawsuit for religious abuse of power.
1912	Modification of Saunière's will.
1913	Hypothetical voyage to Paris.
1916	Pilgrimage to Lourdes.
1917, January 22	Death of Berenger Saunière, at Rennes-le-Château.
1945	the Corbu family buy the Villa Bethania.
1953	Death of Marie Dénarnaud.

This is Saunière's life. It does not list the possible interventions by third parties in his life – that is what we will now investigate.

Chapter 3
Inroads towards the Inner Sanctum

Who is on the list of potential suspects, who could be part of Saunière's secretive circle? That is a difficult question to answer. The only way to work it out is to go through a list of mundane contacts, any of whom could contribute some knowledge to Saunière's secret dimension. This list can be divided into several categories:

From religious circles: Saunière's brother Alfred; his colleagues Henri Boudet, Antonin Gélis and Grassaud; on a purely posthumous basis (from before Saunière's time) Bigou, one of Saunière's predecessors at Rennes-le-Château; the bishop Mgr. Felix Arsène Billard; for the opposite reason, Mgr. de Beauséjour; RP Ferrafiat, a Lazarist from Notre Dame de Marceille, whom Saunière invited to inaugural events of his church.

From secular circles: Marie Dénarnaud, his maid; Emma Calvé, famous opera singer and alleged mistress of Saunière; Derain and Raclet, esoteric booksellers in Lyons who would acquire part of Saunière's library; Joseph Nandrier, a Martinist from Lyons; Soulier, a goldsmith in Lyons; Coindre, jewellery shop owner in Lyons; Roché, notary, doctor and magistrate in Arques; Dujardin-Beaumetz, Jules Doinel, Jules Bois, who we will identify later; at various times (even before Saunière's) the families of Hautpoul (native to Rennes-le-Château), Lupé (near Lyons), Fleury (Rennes-les-Bains), Chefdebien (employer of Alfred Saunière). Others might need to be added to this list – or be removed from it, as our enquiries continue.

Let us begin with our main suspect: Henri Boudet. Like Saunière, Boudet also seems to have had an enigmatic source of income at his disposal. Although Rennes-les-Bains was "much" larger than Rennes-le-Château, it still had only 450 inhabitants. Furthermore, Boudet seems to have had the money to pay for the printing of his book: an indulgence it seems, as the book never became a bestseller and in the end, Boudet actually paid a small fee to have the unsold copies returned to him.

Although Boudet might not have splashed out in as visible a manner as Saunière did, it is still the case that he decorated his presbytery luxuriously. Neither he nor Saunière were from a wealthy family – if they were, they would not have been posted there.

Boudet seems to have been a health freak – or an avid seeker. He is known to have travelled up and down the area, on foot, with charts in his hand, apparently in search of something. Jean Markale described it as "seeking God knows what, but surely not God". According to Boudet himself, he was fascinated by geological anomalies, such as strange rock formations, caves, etc., which could contain secrets or treasures. Fair

The memorial stone in Rennes-le-Chateau, to commemorate the opening of the renewed church. It mentions the presence of Mgr. Billard and Lazarists from Notre-Dame-de-Marceille

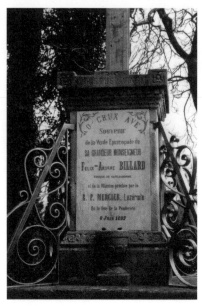

enough – and it rings true, as his archaeological interests are known: his curious book and his membership of the archaeological society are in evidence.
It is known that Boudet and Saunière had a close personal relationship. Whether it was mundane or also secret, that is another question. Furthermore, if secret, it is a question of who steered who. Opinions differ: some believe that Boudet was the old fogey who needed a new, firm pair of hands and enlisted Saunière for that purpose. In our theoretical scenario outlined above, Boudet might have been Saunière's first point of contact to explain the enigmatic discovery he had made.

Saunière arrived in Rennes-le-Château in 1885 and in Carcassonne the following year, with printer François Pomies, Boudet published, "La vraie langue Celtique et le cromleck de Rennes-les-Bains.", (The True Celtic Language and the Cromleck of Rennes-les-Bains). As mentioned, it created both ridicule and questions. Was it a joke? Was it an erroneous interpretation of the archaeological evidence? Or was it a coded message, containing the key to some important secret? Whichever of the above possibilities is the most likely, it would never have resulted in much controversy – had it not been for the mystery of Saunière many decades later. And as badly as the book sold in the 19th century, once the mystery of Rennes-le-Château had come into existence, Boudet's book has gone through various reprints, even translations

But two things are clear: the book predates Saunière's finds in the church; the book is entirely the work of Boudet, with no influence from Saunière. The question, however, is whether the book might have been guided by an unseen hand helping Boudet. After all, we need to stress that Boudet himself did not have personal "mundane" funds to pay for this printing. Let us put Boudet to one side and focus on someone who was buried in his cemetery: Paul Urbain de Fleury. Intriguingly, he seems to have been

buried twice, at least going by the number of his tombs there are in the cemetery.

Born in 1778, he would come into a considerable fortune which would enable him to recover his family's old possessions, and those of his wife's family. He died on 7th August, 1836 and was, as mentioned, buried in the cemetery of Rennes-les-Bains.

Jean Markale observed: "Two tombs for only one man, that is a lot. Especially when it is noted that the dates are deliberately false. Definitely, the Razès is a surprising country. Nothing never occurs there as anywhere else."

One tomb has the inscription "he passed away while doing good", though what "good" it specifically refers to, is not known. Most likely, it was just "general goodness", a reminder of his good life. However, it could refer to how when he passed away, he did some good. We mention this as some have interpreted this inscription as evidence of the possibility – or the fact – that de Fleury was a member of the Rosicrucians, a secret brotherhood that had existed from the early 17th century. Still others see, in these double tombs, the hand of Boudet – alternatively, of course, Boudet might merely have become intrigued by the observation that one former member of his congregation needed two tombs. Fortunately, no-one else in Rennes-les-Bains seems to have had such spatial requirements. Both Boudet and Saunière reported into the bishop of Carcassonne, Mgr. Felix Arsène Billard. Billard was the superior who was either ignorant of Saunière's affaires or approved of them – perhaps even promoted them. He can, however, not have been totally unaware of them. In 1891, at the re-dedication of the church after major repairs, Billard was present – in itself completely logical. But what did Bernard Ponges mean when, in 1892, he indicated that Boudet and Billard were "eminent members of an underground religious fraternity"? This occurred at a time when the "mystery" of Rennes-le-Château did not yet exist, and hence cannot have influenced this assertion. There is more. According to Gérard Moraux de Waldan, who had a copy of this statement, it was openly stated that the goal of this assembly had, among the reasons for its existence, the desire to recover "elements" that they regarded as their property and theirs only.

Despite intimations that Billard and Saunière were very close, it is clear that they did not immediately get off on the best foot. Only a few months into the job, the bishop intervened when Saunière preached against the Republic. Church and State were strictly separated and one major dogma that comedown from the French Revolution was that the days of the kings were gone and that the Church should not try to re-instate them. It was clear that in the days before television, the priests were the opinion-makers of the day. They could influence the voting of

the villagers like no-one else. And criticism of the Republic lay close to many a priest's heart – but could not be aired openly. The young Saunière, however, could not hold back; Billard was forced to intervene and send him to the seminary of Narbonne. After his punishment was over, Saunière did receive a donation of 3,000 francs from the countess de Chambord. She had been of the nobility, and her former husband would in theory have been a potential king of France – if the royals were ever reinstated. Her donation therefore seems to have been a "thank you" to a nice young man, who was obviously a monarchist at heart and loyal to her cause.

Is that all there is to it, or is there a hidden hand steering these events? Was it a coincidence that Saunière was punished? That he was punished and sent to Narbonne? That the countess was made aware of his "crimes"? That she donated money to it, which enabled Saunière to begin the restoration? If the answer to any of these questions is yes, then the only hand that could move Saunière was Billard – and Boudet would be the eyes that observed the movements.

If true, was Billard manipulating Saunière for his own purposes, or for the "greater good" of the esoteric society to which Bernard Ponges alluded? Ponges stated that several priests of the Audois region were affiliated, or sympathised, with a company that was known as "A. A.". In 1985, Moraux de Waldan was able to show a document on which one can clearly read the names of Boudet, Mgr François de Salses, Mgr Billard and several other local priests as members of this organisation.

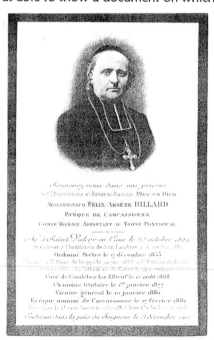

Before going down that road, it is clear that the relationship between Billard and Saunière was nevertheless complex: although you might assume that Saunière would be somewhat vengeful towards Billard after his telling off and subsequent punishment, nothing seems to be further from the truth. Although he would obviously have to invite Billard to the

Obituary for Mgr. Billard

rededication of his church in 1891, there was no specific reason why Saunière should display the arms of Billard at the entry of the church – or leave his name on another monument, just outside his church. If anything, it could be seen as a straightforward example of trying to curry favour. Perhaps Saunière hoped that Billard, given proper "public display and credit" in the restored church, would not ask difficult questions? It is possible, but it is clear that at the same time, this is convoluted thinking.

That is not all. The display of the arms is normally reserved for those of the feudal owners of the places. For churches, a "house of God", it was unusual to decorate them with arms, other than those of celebrated benefactors, influential lords or holy martyrs. It is very unusual to see the arms of the bishop in office at the time of a construction or restorations... unless there was a particular reason.

So what did Saunière do? The church was dedicated to Mary Magdalene, followed by the arms (almost illegible nowadays) of Mgr Leuillieux, the bishop of Carcassonne between 1873 and 1881, then by the arms of Pope Leo XIII. Finally, not knowing what to put in fourth dedication, he put Billard's in. Such doubtful reasoning is hardly admissible.

The presence of Mary Magdalene is understandable. She should stand on the porch of the church of which she is the patron saint. That of a pope, even though he was not a very outstanding one, is also not out of the ordinary. He was the supreme authority for the Church. But the presence of the arms of Mgr. Leuillieux and Mgr. Billard would – should – require more justification. However, no-one has ever challenged it and if they had noted it, no-one has ever made their curiosity public.

There is one final, controversial piece of the puzzle that involves Billard and Saunière. When he broke the story of the mystery of Saunière in the 1960s, Gérard de Sède alleged that when Saunière made his discovery, he went to Billard, who gave him money to go to Paris, to have a document, which he had discovered hidden in his church, translated. For this, it is alleged that Saunière went to the seminary of St Sulpice, in the heart of Paris. During his stay, he allegedly mixed in the upper crust of the Parisian social circles, where he allegedly befriended, then courted the famous opera singer Emma Calve. The problem with this story is that there is no evidence for it. It originated with de Sède, and where he got it from (if not from his imagination), is not known.

Let us therefore direct our attention to the memory of Monseigneur Leuillieux. His inclusion in the dedication on the church does not seem to be the consequence of a particular act on his behalf for Saunière. Leuillieux was bishop from 1873 to 1881. At the time of this ministry, Saunière was ordained (in 1879) and immediately became the vicar of Alet-les-Bains,

Coat of arms of Mgr. Billard

before being posted at the village of Le Clat
(1882-1885). Did Saunière want to include
Leuillieux as he had been ordained priest during
his term of office? Perhaps... or could there more
to it than that?
It is clear that this bishop has been relegated to
oblivion a little too quickly by most researchers,
as fast as the disappearance of his arms from the porch of the church of
Rennes-le-Château.
We should note that our bishop showed a great interest in the church of
Notre-Dame-de-Marceille, close to Limoux. It was Leuillieux who carried
out an old project of a certain Mgr. Fouquet, the bishop of Narbonne in
the 17th century, who had dreamt of installing Lazarist missionaries there.
This dream was finally realised in 1873.
Bishop Fouquet was a brother of Nicolas Fouquet, one-time Minister of
Finance to the French king Louis XIV and often named as part of the
mystery of Rennes-le-Château. Intriguing, but in 1873, Saunière was a
very young man, not even a priest. He had not even been ordained
when Leuillieux initiated a procession at Notre-Dame-de-Marceille in the
honour of the "Miraculous Virgin", in 1877.
However, let us remain a bit longer at Notre-Dame-de-Marceille. In 1883,
Saunière was officiating at Le Clat at the time when Mgr. Billard, at the
time of the fiftieth anniversary of the Conferences of St-Vincent of Paul,
spoke about the Virgin in front of his diocese, in connection with the
first difficulties of the Church of France vis-à-vis the government. In 1878,
at the conclave to elect the new pope, eventually won by Leo XIII,
Billard was one of those who took part in the election procession – even
though he was a bishop at that time. When Saunière was posted to Le
Clat in 1884, Pope Leo XII granted certain favours to Notre-Dame-de-
Marceille, specifically exceptional privileges in connection with the five
festivals of Holy Virgin. But nothing of these actions directly affected
Saunière. Nevertheless, somewhat bizarrely, Saunière did invite Lazarists
to the rededication of his church. Furthermore, they were signalled out
for mention on the memorial stone in front of the church. Though it is
not extraordinary to invite Lazarists to this rededication ceremony, it is
not an obvious think to do. On the mundane level, Saunière and the
Lazarists had never had any dealings with each other. And not only did
he invite these Lazarists, on the memorial to the service, the Lazarists are
specifically mentioned, together with Mgr. Billard. Although the memorial
is often photographed and sometimes used as evidence of the "special

bond" between Saunière and Billard, the inclusion of the Lazarists is the anomalous detail, which has never received its due attention.

Mgr Billard died on Tuesday, 3rd December, 1901. Among the many obituaries proclaiming in chorus the merits of the bishop, there is one of the "La Délivrance". This small text mentions a fact now generally forgotten: Billard had devoted an enormous amount of labour and most of his resources to the rosary, so much so that he was given the title of "Bishop of the Rosary", just like His Holiness Leo XIII could have been called the "Pope of the Rosary". In addition, we know and repeat that Mgr. Billard, when general vicar in Rouen, was in the company of the Cardinal de Bonnechose for the conclave that would elect Pope Leo XIII in 1878 (1878 - 1903). Upon his return from this conclave, he was appointed bishop of Carcassonne, after the death of Leuillieux.

Despite the paeans of approval for the life of Billard on one level, on another level, it would seem that Félix-Arsène Billard did not always behave in a manner worthy of a bishop. Pierre Jarnac has shown that during his time as a prelate, there were acts of simony, perhaps embezzlement, and a sordid affair regarding the will of Mrs. Rose Sabatier, who in some "strange way" bequeathed all her fortune to him. In the same vein, we learn that at one point, Mgr. Billard was suspended for three months by the Vatican.

Perhaps it was the reprimand that brought him closer to Saunière, who had been reprimanded by Billard himself? Perhaps Billard's own shady dealings meant that he tolerated Saunière's own "private enterprises"? Perhaps de Beauséjour was a much more noble and honourable man, who could not keep his eyes closed to Saunière's crimes? Perhaps, but, then again, it does not explain why Saunière stubbornly refused to show his accounts. Again, the only thing that de Beauséjour wanted to know was the source of Saunière's income. If it was illegal, he might have been suspended by the Church, but that fate befell him anyway. It might be, therefore, that there was "more strangeness" going on.

Let us introduce a member not on our original list: Emile Hoffet (1873-1946). Hoffet was an exceptional scholar. He is claimed to have been a palaeographer, polyglot, well-known cryptographer, and also devoted to detailed research into the history of Christianity.

He was a member of the Congregation of Missionaries of the Oblats de Marie, and the nephew of Bieil, the director of the seminary of St Sulpice in Paris. It is stated that Hoffet was the person, whom Saunière contacted in Paris, to have his curious find analysed. As previously stated, there is no evidence to support this trip to Paris, or the "fact" that Saunière's discovery was a text that required cryptographic decoding.

Nevertheless, what is largely not known about our suspect Hoffet is that he was well-versed in occultism, originating from Christian esotericism.

He approached religious movements that were directed towards organisations such as the already mentioned A. A., to which we will return later.

Hoffet is believed to have been the go-between who introduced Saunière to Emma Calvé. She herself apparently had a profound interest in esotericism, attending meetings that were held in the "Independent Art bookshop", and to which Claude Debussy also went.

To repeat: the claim of a relationship between Calvé and Saunière is not supported by any evidence. Seeing that the claim was made by André Billy in the columns of Figaro magazine, in 1968, it should be seen as a news-stand magazine trying to inject some "amour" – love – into the mystery of Rennes-le-Château, which was then unfolding in the French press.

The only question we want to ask is whether, if true, Emma Calvé could indeed have been used as a "liaison" between Saunière and the "movers in the shadows".

Rosa-Emma Calvet was born on 15th August, 1858, in Décazeville, the child of Léonie-Adèle Astorg and Justin Calvet. She was raised by her aunt, Mme Caylet. According to Jean Markale, she was a remote cousin of Melanie Calvet, famous as the shepherdess who saw apparitions of the Virgin Mary at La Salette. However, that was obviously not the reason why she changed her name: Calvé looked and sounded better than Calvet for an upcoming artist.

When she was finally a famous opera singer with an interest in the occult, she frequented the same Parisian circles where in 1888, the "war of the roses" would be fought: the battle between Marquis Stanislas de Guaïta (the renovator of the Rosicrucian brotherhood) and the "black magician" Boullan, a defrocked priest, who practised sorcery in Lyons. Ten years later, Saunière would be in Lyons – but there is no evidence to close this circuit.

In 1894, Calvé acquired the famous castle of the Cabrières, in Rouergue, near Millau. This strange manor house was said to be a high place of occultism and regional esotericism. Tradition has it that in its secret underground tunnels, the fabulous manuscript of Abraham the Magician was secreted away. It is alleged that this document was owned by the famous alchemist Nicolas Flamel. Flamel was just one of many people alleged to have handled this document. Pierre Borel corroborated this rumour in 1655, stating that he had heard from a gentleman of Rouergue, M. de Cabrières, that the document had been kept in his castle, where he had the original book that Cardinal de Richelieu had recovered before it was cast into a fire.

It took Calvé ten years to renovate her castle; she received help from her father Justin Calvet, who was a builder. Intriguingly, his specialities were

mining and underground building projects. Some researchers have argued that there is an overlap between the periods when Saunière performed his restoration, and Calvé did hers. Even if that were the case, does it explain anything, or does it double the mystery?

Still, like Saunière, Calvé seems to have got into debt at the end of her life, and sold her castle of Cabrières to the woman alleged to be the lady of the manor of Creissels, who was said to have been the tutor of the Habsbourg children for a period of ten years. If true, the next question is whether it is important – after all, only a limited number of people, i. e. wealthy people, can buy castles.

Jean Contrucci has stated that it is certain that the singer knew Emile Hoffet very well. For Gérard de Sède, this Parisian priest would be Saunière's contact while in Paris for the documents he was alleged to have found in the pillar of the church of Rennes-le-Château. But if, as we think, these parchments are forgeries, the contact with Hoffet would never have occurred. Therefore, although it is clear that Hoffet and Calvé had their fair share esoteric contacts, none seem to lead to our French village priest. We can therefore remove Hoffet and Calvé from our lists of suspects.

Except... It is not so much evidence that Calvé and Saunière knew each other, but rather that they moved in the same circles and knew the same people – without knowing each other personally.

Emma Calvé attended many mediums and esoteric seances, mostly held in the "Bookshop of the Marvellous", founded by Chamuel and Papus. In a back room of this establishment was the centre of Parisian occultism, as well as the seat of the Martinist Order, renovated by Papus in 1891. Such closed meetings were the breeding ground for Stanislas de Guaïta. Emma would meet Edouard Bailly here, a man who would influence the journalist Jules Bois. Bois was interested in demonology and would lead the singer into practising the occult.

Furthermore, Papus, or to use his real name Gérard Encausse, gave an Honorary Diploma to Emma Calvé on 11th November, 1892. Papus also used Lyons as his base; it was from Lyons that he sought the creation of a group of Martinists in Toulouse. It is from the same Lyons address that several invitations to attend were sent to Saunière's Lyons' residence. Therefore, if the two, Calvé and Saunière, ever met – however unlikely this may be – it seems that the Martinist lodge in Lyons is a better chance for any such meeting to take place than chance encounters some years earlier in Paris.

27

Chapter 4
Shades of Lyons

We have previously gone into some detail as to the reason why Saunière might have had a residence in Lyons, in the period 1898-1900, but it is necessary to repeat them here.

The presence of Saunière in Lyons can hardly be debated, because of the existence of documents found with his name and address on it. Although these provide conclusive proof, there is no mention in the priest's "mundane notes" of his presence there. It is bizarre, for if Saunière had an "un-secret" desire to stop in Lyons, he could do this without arising any suspicion. After all, it is not forbidden to spend a period of time in a different city. It is the absence of this sojourn in his notes that arises suspicion...

It is clear that if he went to Lyons, he did not have to tell anyone he was going there. Although the villagers would probably notice his absence, did they know where he had gone to? He might have said he was going to Paris, a journey by train that would take him through Lyons, specifically Lyons-Perrache station, which was a compulsory stop on this route.

It is in Lyons where we find two bookshops that purchased parts of Saunière's library after his death: the first is the Gacon bookshop (14, rue de la Félicité), the second Derain-Raclet (81, rue Bossuet at that time). When the Derain stock was liquidated, a lucky purchaser found three books carrying the ex-libris of "François Béranger Saunière Priest at: Aude, town of Rennes-le-Château", followed by the numbers of the ledger. These works were:

· La Prophétie des Papes attribuée à S. Malachie (The Papal Prophecy attributed to St Malachy) by abbé Joseph Maitre;

· Histoire des Grandes Forêts de la Gaule et de l'Ancienne France (History of the Great Forests of Gaul and Ancient France) by L.F. Alfred Maury;

· Monuments celtiques. Ou Recherches sur le Culte des Pierres. Précédées d'une notice sur les Celtes et sur les Druides, et suivies d'étymologies celtiques (Celtic Monuments. Or Researches on the Cult of the Stones. Preceded by a note on the Celts and the Druids and followed by Celtic etymology), by M. Camby.

These books in themselves are not remarkable. They are not rare and hence more local bookshops could have bought them, rather than a distant buyer from Lyons. But rather than being bought by bookshops in Carcassonne, Toulouse, Perpignan, or Narbonne, we suddenly find not one, but two Lyons bookshops purchasing his library. They would only have been able to purchase these if someone had told them that the books were up for sale. And that meant someone told them.

Although Saunière is a well-known figure now, before Gérard de Sède's books were published in the 1960s, he was unknown – except in a very small area around Rennes-le-Château; definitely not elsewhere... unless, of course, as we now know, he was known in Lyons as well.

What did Saunière do in Lyons? Again, we have covered this in an earlier publication. He seems to have gone into the country, specifically to the Pilat region; he purchased powerful photographic equipment, and he corresponded with one "S. Valon", a goldsmith, a Mr. Coindre, a jewellery shop owner, and a Mr. Soulier, rue Victor Hugo, all from Lyons.

Based on these documents, we were able to conclude that Saunière was present in Lyons in May and June 1898, September 1899 and May and June 1900 – a total of three trips, though possibly more. There is no evidence however of any other trips and unless that becomes available, we need to limit his presence in the city to these three trips.

It is clear that these short stays must have had specific reasons – reasons, which apparently ceased to be after June 1900. The documents also show he had specific needs – very specific needs when it comes to his photographic material, which was very professional and not kept in stock by the shop from which he tried to buy it. Note that this was not some small town, but Lyons, the second biggest town in France.

So how did the bookshops find out about Saunière's death? The founder of the Derain bookshop was a well-known figure in esoteric circles, specifically in Martinist and Masonic circles. Apart from selling books, he also published books, specifically on esoteric subjects.

Whether Martinism played a vital part in the "mobility" of certain actors in the mystery of Rennes-le-Château is a question that has been posed more and more in recent years. It is true that Martinism was a movement that was rapidly becoming very popular, a rise that coincided with Saunière's rise to wealth.

What was it, apart from an "Inner Way"? Martinism is mentioned for the first time in the work of Martines de Pasqually, when discussing the Fall and possible Redemption of Man. Martines de Pasqually, from whose name the movement took its name, was a strange character, who was born in Alicante in 1671. Although he claimed that his doctrines remained strongly rooted in Catholicism, nevertheless it is tinged with impressive

theurgic and Kabbalistic knowledge.

Martines had two famous disciples: Jean-Baptiste Willermoz and Louis-Claude de Saint Martin. He was affiliated to the Masonic lodge "La Française" (G.L.F.) and between 1754 and 1764, he founded his "Ordre des Chevaliers Macons Elus Cohens de l'Univers", based on the model of the Masonic lodge. The order would receive many initiates from the Languedoc, Lyons and Paris.

Martines died on 29th April, 1772 and his order was dissolved in 1781. His disciple Jean-Baptiste Willermoz was a notable citizen of Lyons, fascinated by Freemasonry. In 1753, he had founded his own group, "La Parfaite Amitié". He would remain faithful to the theurgic system of Martines even after Saint Martin had embarked on a course that would go in the opposite direction to the principles of Freemasonry. Willermoz would be the principal founder of the "Rite Ecossais Rectifié" (R.E.R. – The Scottish Rectified Rite), which is still an operational system of masonry today.

Another important figure in Martinism in Lyons, in Saunière's time, was Gérard Encausse. Encausse was born on 13th July, 1865 in La Coruña, in Spain. Later, he became known under the pseudonym Papus, and founded the Martinist Order, directed by a Supreme Council.

However, it can be said that his meeting with "Philippe de Lyon" was a decisive moment in the life of this initiate. Philippe de Lyon, the pseudonym of Nizier Anthelme Philippe, did not openly belong to any secret organisation. However, he seems to have been unquestionably a vital element for the expansion of the Lyons Martinists. He designed a pentacle specifically for the Order and a medal worn by the Martinist dignitaries.

Perhaps it is important to note that the meeting between the two men took place under the directive of Saint-Yves d'Alveydre, a man who would become famous for the concept of "synarchy". Synarchy is the opposite of anarchy. Anarchy tries to break down the existing social hierarchy by intrusive, often terrorist activity. Synarchy infiltrated that hierarchy and tried to take it over from within, without ever identifying itself as being involved in such a take-over. Synarchy is obviously the model that is most closely identified with "secret organisations". The allegation that the members of the English police forces are all Freemasons is one example; another is the allegation that the Yale "secret brotherhood", Skull and Bone, is infiltrating American politics. However, such examples were largely unheard of a century ago, and it was only several decades after d'Alveydre preached his concept, that the effects of his teachings became visible.

Between 1900 and 1906, Papus and "M. Philippe" went to the Russian court, where they were received with benevolence and attention. "Of

course", by a complete coincidence, the Protocols of the Elders of Sion were put into circulation between 1901 and 1905. In his popular book Mein Kampf, Adolf Hitler used the Protocols of the Elders of Sion to "prove" deceptively that a global conspiracy was afoot. Unsurprisingly, he argued that this conspiracy was led by the Jews. Despite disastrous effects during the Second World War, nevertheless the allegation has stuck and frequently, Jews such as Henry Kissinger continue to be blamed – or identified – as part of a synarchic Jewish plot to take over the world.

Recent research has argued that the "Lyons synarchists" might have been responsible for the release of this document, which would become one of the defining documents of the 20th century. This conclusion would definitely make sense. According to Jean Saunier, Papus – synarchist – would indeed have wanted to show that the political heads of state were not the true leaders of this world, but that they were in fact manipulated by a small cabal of people behind the scenes: an international council of modest, largely unknown, though high financiers and associates – though not necessarily Jewish. These were allegedly the real powerbrokers, instigating social reforms, without belonging to visible organisations or companies. These men were allegedly brought together in small groups and created the tools to bring about change in selected countries. They acted according to an old science of social organisation, originating from the ancient sanctuaries of Egypt and preserved piously in certain centres; it was known as "Hermetic".

If Papus was indeed the creator of this document and if this was indeed what Papus tried to aspire to, then suddenly we find Saunière mingling with people, who were not only very secretive, but who were also highly ambitious. It also means that Saunière's double life was a double life that was carefully planned by him, to fit the synarchist model, in which small-time village priests like himself might have access to the broadest corridors of power. More importantly, we need to wonder whether the mystery of Rennes-le-Château might be at all related to these

ambitious plans – or whether that is a coincidence. One intriguing character involved with such synarchic plots was another priest by the name of Roca. Born in 1830 and ordained in 1858, he was appointed honorary canon of Perpignan in 1869. A well-travelled man, he dreamt of modifying the Catholic teachings, which he felt had become "dead writings" for the benefit of the "greater mystery of Christian esotericism". His thesis quickly

Joanny Bricaud

31

obtained excellent reviews in theological circles. Roca consequently published many works filled with a prophetic vigour: in 1884: "Christ, the Pope and democracy; the fatal Crisis and the safety of Europe; A critical Study on the missions"; in 1886: "End of the Old World"…to quote but a few.

He does not hide that he is an enthusiastic admirer of Saint Yves d'Alveydre, and endorses the prediction of Joshua: "And I will choose myself in all Mankind an elite of spirits, which will become the priests of my new ground and my new heaven."

He adds however: "These Missionaries are not to come, they are already on Earth and they are the new apostles." (Glorious Centenary: 1889, New world, new skies, new ground. Published in Paris by Auguste Ghio, in 1889).

The dream of Roca became neither more nor less than the installation of an Order of Synarchical priests, whose pioneers would come from the Languedoc, the area of Saunière, Boudet and Billard! In 1885, Roca would also enter into talks with some Masonic lodges of the Grand Orient of France… and even propose to Rome a first protocol. The Vatican answered very quickly, but it was to firmly require of Roca to put a stop to his delusions. But Roca never retracted, even though the Order of the Synarchical Priests died before ever seeing the light of day. Nevertheless, it was the "Order of the Star" that ensured the secret survival of this principle, originally financed by Mme. Piou de Saint-Gilles and Albert Jhouney. One of its famous members would be one of the owners of the castle of Bugarach, near Rennes-le-Château.

Roca and Saunière were contemporaries; the periods when Saunière worked on his church and Roca wrote his books coincide. But there is no clear evidence that the two ever met. Although it is clear they might have operated within the same framework. The list of Roca's works were found in the list of books purchased by the Lyons bookshop Derain-Raclet from Saunière's library. It is obvious therefore that Saunière was aware of Roca's writings.

Could Saunière have been a Martinist? We mentioned that there is evidence that while he stayed in Lyons during 1898-1900, he definitely was invited to attend meetings of the local Martinist lodge. Did it go any further than that? As to the question whether he conducted his life according to that of a "Martinist member", the answer is yes.

One "S. Valon", first name unknown and of which there is no evidence in the marriage records in Lyons, seems to have been involved in the Martinist lodge of Lyons. He was also Saunière's contact for his enquiries about jewellery. His home was in the St Just and St Irenée district, close

to the dwelling of another jeweller, Soulier, and within close distance of the house of Joanny Bricaud, future leader of the Martinist movement after Papus' death. If there ever was contact between Saunière and Bricaud, then geographical vicinity would definitely have brought their paths close – if not together. It should be added that at one point in his life, Bricaud was a priest himself.

But could Saunière's interest in Martinism have explained his secretive nature? That is unlikely. There were no specific directives from the Church that priests could not enter or were requested not to join the organisation. Martinism was perfectly "Christian" and did not work for anyone who did not worship Jesus Christ, however much esoteric veneer was added to the experience.

Finally, the files of the Martinist lodge at Lyons have hand-written notes from Papus and correspondence with members and other lodges. Some of this information is interesting. Lodge No. 23 was founded in 1893 by Elie Steel or ALTA, the pseudonym of the Bouchet bookseller, living in 17, rue de Sully. This lodge had amongst its members the jeweller Beau, Boride and in particular, Bricaud. In 1895, Gabriel Rivoire (lawyer at the court of Lyon) was asked by Elie Steel to request Papus to transform the "Cercle Catalan et Roussillonnais" and the "Fraternité Lyonnaise et Catalane" – of both of which he was president – into a Martinist lodge. Rivoire was known in theatre circles as an unconditional admirer of Emma Calvé. Finally, we should note that we do not have any evidence that Soulier (the goldsmith) and Coindre (the jewellery broker) attended any such meetings. However, absence of evidence does not mean evidence of absence… although of course not everyone Saunière might have met should, by default, have occult connections.

At this stage, we can sum up the circles in which Saunière moved when away from Rennes-le-Château:
Contact with Martinist circles:
· Three Lyons booksellers specialising in esoteric subjects, including two strongly connected with Martinism: Derain and Bouchet. Remember that Derain purchased part of Saunière's library.
· a goldsmith Martinist: Beau.
· Bricaud, who lived near the location where mail addressed to Saunière in Lyons was delivered.

Practical contacts:
· a goldsmith and a jewellery shop owner.

Lastly, and a little more distant geographically, it was in Isère where Gérard Moraux de Waldan recovered documents related to the "A. A.",

writings in which the names of Henri Boudet and Mgr Billard are found as members of this group. But before we look into this A.A., which so far remains our best candidate, we need to look into the possible Masonic connections. After all, they have been implicated in most mysteries of the past century.

Chapter 5
Masonic echoes

To approach the topic of Freemasonry in the history of Berenger Saunière and Rennes-le-Château could be a delicate task. Indeed, one could wonder what this "discreet organisation" would do in such a turbid enigma. We won't claim that we can bring direct or precise answers to this question. But we need to ask the question and it would be equally awkward to deny that this fraternity was not involved at all in this fresco. To begin with, there is François de Chefdebien. It was in 1780 that the marquis François de Chefdebien, member of the notorious "Directoire Ecossais de la maconnerie", entered the "Société de Philadelphes" with his father, the Viscount de Chefdebien d'Aigrefeuille. He was the author of a History of Masonry, published in 1779. The marquis represented Occitania at a Masonic Convention at Wilhelmsbad. At this conference, François de Chefdebien spoke about the existence of "Unknown Templar Superiors", who have the responsibility of supervising the destiny of Freemasonry. This theme would grow in popularity in the coming centuries, with many now believing – largely without evidence – that the Masons are the secret continuation of the Knights Templar.

De Chefdebien retained a priest, Alfred Saunière, brother of Berenger, to work for the de Chefdebien family. According to Gérard de Sède, Alfred Saunière would have been in a position to study any documents or family files with ease and thus be in a superb position to know this order's history.

Another character in this saga is Jacques-Etienne Marconnis de Nègre, who was initiated in 1833 in the Masonic rite of Misraïm, instituted in Vienna. Marconnis de Nègre was of the same family branch as the "Dame d'Ables", the Marquise of Hautpoul, whose tombstone is one of the major features of the mystery of Rennes-le-Château. Her tombstone was located in the cemetery of Rennes-le-Château and involved in the controversy, as it is believed that Saunière defaced the tombstone during his "restoration" of the cemetery.

Expelled twice from the Misraïm rite (initially in Paris under the name of Marconnis, then in Lyons under that of "Negro"), he created the "Lodge of the Disciples of Memphis of Cairo", on 28th May 1815, in Montauban. This became the Mother Lodge of the Rite of Memphis in France, which would have Samuel Monis as its Venerable Master. On 21st January 1816, Marconnis was elected Grand Hierophant of the rite, which was based on the Egyptian Mysteries.

On 23rd March 1838 (the day after the spring equinox) the son of

Marconnis de Nègre instituted a lodge under the name of "Loge Osiris" in Paris. In Brussels, on 21st May of the same year, he founded the "Lodge of the Benevolence". The rite of Memphis would be prohibited by a police decision, from 15th June 1841 to 5th March 1848 and again from 1850 to 1853.

On 24th June, 1908, the Rites of Memphis and Misraïm were fused. On this date, we find Gérard Encausse of Lyon (Papus) having the title of Grand Master and Charles Détré of Lyons (Teder) the rank of assistant. Joanny Bricaud was another member of this movement, which received the charter of "Sovereign Sanctuary of Memphis-Misraïm". Many meetings of this order were held in the Aude, in Arques, near Rennes-le-Château. Finally, we need to add that the branch of the de Nègre family, which gave birth to both Marconnis and Marie d'Ables, came from Le Clat, where Saunière was the priest from 1882 to 1885, his posting before Rennes-le-Château.

It is clear that Marie de Nègre was a member of a Masonic family. Was the family of her husband, the Hautpoul, also? According to Gérard de Sède, several Hautpoul brothers were affiliated with lodges of the Scottish Rite: François-Pierre, Eugène, Armand, Théobald and Charles. These men could therefore have been buried with important Masonic documents – but that is only an assumption. However, it is certain that masons often had the desire to be buried with at the very least interesting ornaments and documents… last wishes, which were normally always respected. Their tombs would therefore be veritable treasure troves of information. It has been alleged that Alfred Saunière, brother of Berenger, concealed or sought in the files of the Chefdebien family documentary evidence relating to a certain Masonic secret. If so, why could Bérenger Saunière, in dialogue with his brother and other people implicated in the affair, not have possessed information confirming the existence of key documents hidden in a tomb of a member of the Hautpoul family? If this were the case, it would have required an act of violence to violate a burial in order to recover its contents and to reap the rewards of the spoil. Admittedly, the assumption is at the moment without foundation. Nevertheless, it should be aired, as many elements in the enigma of Rennes-le-Château are closely related to the Hautpoul family, their castle and their tombs. Moreover, it is clear that many of their menfolk had Masonic connections, such as the Lodge of Wisdom in Toulouse.

In the vaults of time, there are also other connections between this family and the city of Lyons – connections, which might explain Saunière's movements. Michel Lamy stresses that as early as 1778, Alexandre Lenoir annexed the Rank of Beneficial Knight of the Holy City to the Scottish Rite in Lyons. He was a relative of the Hautpoul family, via Olivier d'Hautpoul, the son of Angélique Lenoir. Later, François d'Hautpoul

would be Venerable Master of the Lodge Carbonari of Limoux. Lenoir would have been on the list, created by the Republic of Venice, of those, who had to be targeted, as it was necessary to stop the spread of their knowledge, deemed dangerous to the Church (as mentioned by Mgr. Amand Joseph Faba of the Company of St Augustin in Grenoble, 1888). Finally, let us note that the Lodge of Wisdom existed in 1834. It consisted primarily of aristocrats faithful to the count de Chambord, Henry V, who was exiled in Austria. Linked with this lodge were Eugène, Charles and Théobald d'Hautpoul. It was also a member of the Hautpoul family who was the tutor of the de Chambord children in Austria. "Obviously" by "pure coincidence", the countess de Chambord donated a substantial amount to Bérenger Saunière, allowing him, upon his return to his parish, to commence the most urgent work in his church. It was more than necessary, and could perhaps have been used as a smoke screen in order to recover certain elements hidden in this church.

This suggests a scenario wherein the restoration of the church and cemetery that held the bones of the Hautpoul family was carried out at the request of the only person willing to pay for it: the countess de Chambord. Though logical, the one question unanswered is how she found out that a donation would be appreciated.

Another character in the Masonic circles of the time was Henri-Charles-Etienne Dujardin-Beaumetz (1852-1913), who was initially an artist plying an art that could not support him. Hence, he quickly chose a political career in order to feed himself. He became a member of the General Council in Limoux, and was then appointed to the Aude departmental council from 1889 till 1912, when he was finally be named under-secretary of State for the Arts. He was a party radical and a notorious Freemason. Though of the same period, it seems that he and Saunière had nothing in common. Nevertheless, the two were known to each other when Saunière was in Alet in 1879, and formed a bond, which would last until Saunière's death. But even though the relationship between these men was as solid as rock, what could the two discuss, as they seemed to be of opposing persuasions with nothing in common? Because of his interest and background, Dujardin-Beaumetz and Saunière might have shared their passion for art, if not history and archaeology. At the same time, Dujardin-Beaumetz might have been the party who was able to throw a symbolic light on potential discoveries in his church. The year that Saunière made his discoveries, Dujardin-Beaumetz changed membership from the "Très Révérante Loge La Clémente Amitié" to the much more discreet "United Brothers".

Another "brother" was Jules Doinel, one of the haziest characters of all those masons, who would enter into "Saunière's Fraternity". Doinel was archivist for the departmental services of the Aude region and before

that, he held that same position in Loiret. We find him making numerous visits to Rennes-le-Château, but always making sure they are discreet. Nevertheless, if Saunière wanted advice on certain symbolic decorations for his church, Doinel would have been the ideal candidate to provide such information. Doinel was both a Mason and a Gnostic and in 1889, was the founder of a Gnostic fraternity, which ventured into obscure spiritual doctrines and rites; under the name of Valentine II, he created "La Gnose Ecclésiastique". As archivist in Orléans, he must have been in contact with the priory of Saint-Samson, a priory which was said to have shielded the "Priory of Sion", the alleged organisation that was behind Berenger Saunière. Doinel was quickly recalled on orders of the bishop of Orléans and started to write anti-masonic literature, under the pseudonym of Jean Kotska. But before long, he would dedicate himself once again to his original interests.

Another brother was "Cros". We do not know to which "Cros" Saunière refers to in his personal notebook when he writes, on 29th September 1891: "Saw priest of Névian. At Gélis. At Carrière. Saw Cros and secret." There are two candidates. One is the bishop of Carcassonne's vicar-general, Charles Cros, and the other, undoubtedly related to Charles, is a Freemason. Whoever of the two possibilities it may be, the solemn reference that Saunière made in his diary is intriguing.

Ernest Cros was born in 1842, in Fabrezan (Aude). He became a professor in Limoux, where he also came into contact with occultism; his name appeared on the list of Freemasons known to the Vichy government. This regime was vehemently opposed to Freemasonry and therefore they would not joke about the names on this list. It was compiled from documents that had been plundered from the archives of various lodges. If he is mentioned on this list, it means he was a member. Any argument against this fact is only raised because some people have found it fashionable to query his membership, an argument based on no contradictory evidence except the desire to debate and be heard.

Like Doinel, Ernest Cros, would always remain a faithful friend of Berenger Saunière. This faithful friendship between two masons and a priest could and should raise questions. How could these characters, in theory completely opposed on philosophical, political, religious and social grounds, be friends? And maintain their friendship? If they had opposing ideologies, then it seems that common research, shared interest or converging goals kept them together.

Ernest Cros was to be the person who made a famous statement on the "Coumesourde flagstone", discovered sometime around 1928, among the rocks on the mountainous sides of Coumesourde, close to Rennes-les-Bains. According to Gérard de Sède, this flagstone was engraved on request of the Marquis de Fleury – the same Marquis who apparently

required two tombs in the cemetery of Rennes-les-Bains, who "passed away while doing good". Was that Ernest Cros the same Ernest Cros we have been talking about? If all these connections are as straightforward as they appear to be, then with one stroke, several elements of the enigma have suddenly been strung together. We thus would have a clear-cut connection between Saunière and Boudet, Ernest Cros, the Marquis de Fleury, the flagstone of Coumesourde and Freemasonry. But where does it all lead?

Let us introduce the final few suspects. The name Jordy might appear to be totally unfamiliar to all, except to those who are aware of a rumour about the postcards of the village, published by Bérenger Saunière. These postcards are centred on the church and the immediate surroundings of Rennes-le-Château. How many cards there were in the set often differs from author to author. Some say there were 33, a definite Freemasonic number if it were the case. Nevertheless, we think that number is greatly exaggerated. 33 different postcards in circulation for a small village such as Rennes-le-Château, in 1900, when it was not a tourist attraction? This seems very unlikely.

Nevertheless, it is clear that there could have been Masonic triads working in the background. One such group might have been made up of Berenger Saunière, Déodat Roché and Jordy. There was a doctor in the Roché family who was Bérenger Saunière's personal physician. This man was around when Saunière's health declined, perhaps as a result of the continued attacks by Mgr. de Beauséjour. There was the notary Roché, who was Saunière's adviser in many of his administrative affairs. Finally, there is Déodat Roché, the first magistrate of Arques. It is obvious that the Roché family was a veritable pool of knowledge in the area and though each of these individuals had to be professionally discreet, one can wonder whether together, perhaps after Saunière's death, they did not discuss his "affairs".

Déodat Roché was not only the magistrate of Arques, he was also fascinated by Catharism. He was the man who welcomed a certain "Mr Laurence" to the hamlet of Les Pontils, on the grounds of which the famous "tomb of the Shepherds of Arcadia" was located. The tomb is identical to a tomb depicted in a painting by the French painter Nicolas Poussin, although it is known that the tomb post-dates the painting by several centuries.

Déodat Roché could not have been unaware of what occurred on that estate, nor the strange visitors, who were spotted there. The mayor was an "informed amateur" who knew his community; furthermore, any administrative documents were held at his office. This not only applied to the site of this tomb, but everything that occurred in Arques: the castle, a standing stone, some cavities that a few people knew of, a

quarry with apparently abandoned stones engraved with strange signs, etc.

His circle of influence, however, was much wider: he was also the president of the court of Castelnaudary, Limoux and Carcassonne. Combined with a passion for the history of the Languedoc, specifically on the topic of the Albigensian Crusade, whose main focus was the destruction of the Cathar religion, Roché was a source – and collector – of information. No wonder then that he would be labelled the "Cathar Pope", nor also that he was a member of a secret society. Some of the more extraordinary allegations made about Roché are obviously absurd, but it is true that he had strong Masonic allegiances.

We also know that Roché was interested in the mystery of Rennes-le-Château, together with Lucienne Julien. Both of these invited visits from Daniel Bettex and George Cagger, the latter better known under his pseudonym "Pumaz" and the author of a work decoding the tombstone of the "Dame de Hautpoul". Roché's allegiances with Martinism and the Grand Orient meant that the Vichy government decided to remove him from his magisterial functions. Of course, it was an excuse; in reality, Roché had become a cumbersome figure, disobeying his superiors or perhaps rather going his own way, this in an area of which he knew both the official and unofficial history.

But specifically, it is known that Roché knew V. Jordy, the photographer, also known as the "Venerable Master of the R.L.", the "True Friends Reunited". Roché ordered a sets of postcards from Jordy himself, as had Saunière before him. Can we really assume that Roché, his family closely aligned with the events of Rennes-le-Château, never discussed the matter? Rather, it seems that in all these circumstances, we have a set of people with converging interests – and connections.

That, of course, can be expected from a Masonic brotherhood – to some extent, that is what they were there for. Is it sufficient evidence to explain the mystery of Rennes-le-Château? The Masonic network could explain how Berenger Saunière was able to get money for essential repairs to his church. But that donation from the Countess de Chambord was above board – it was not a secret. The secret began afterwards. It seems, therefore, that the Masons are not guilty.

After all this, it is clear that the best evidence is the reference made in 1892 that Boudet and Billard and Saunière were member of a secret society, and that this society was the A.A. So what is the A.A.?

Chapter 6
From AGLA to A. A.

There was a "movement" named AGLA about which we know very little. As a secret society, it maintained its nature very well. It seems they were an underground movement, not very active, and often merging with something called Angelica.

However, this is a dubious statement to make: as they were little known, bluntly suggesting they were not very active is dangerous, owing to the fact that we do not know anything about them, which means we know nothing about their activities or frequency thereof either.

Was it a "subgroup" of Angelica, or was it autonomous? Robert Ambelain defines AGLA as an autonomous society and firmly closed. He suggests that rather than a subgroup, they were in fact the group behind a more visible organisation, like for example, the organisation led by another priest, Nicholas Montfaucon de Villars, author of "Count de Gabelis", subtitled "The Extravagant Mysteries of the Cabalists, expounded in Five pleasant Discourses on the Secret Societies." The book which appeared in 1670, was a treatise on the occult and elemental sex magic, assuring its ban in France, even though it sold out several editions in the first few months. Nevertheless, it had no known author, until Montfaucon's name was advanced. He was a well-known figure, a "Libertin", an intellectual whose ideas were deemed dangerous both for the church and the king. In March 1673, De Villars was murdered by a rifle bullet, near Lyons. His murder was never solved, but René Nelli believes that Montfaucon de Villars had been assassinated, possibly because in his book, he had revealed "too much".

What could this secret be that had to be protected at all cost, even with the life of this priest? This question remained unanswered, but raises another, almost identical one: what could be the secret that had to be protected at all cost, even with the life of the priest Antonin Gélis? No answer has ever been provided for his murder either. That murder occurred on the evening of 31st October, 1897, in his presbytery. Newspaper accounts relate how Gélis was found lying in a pool of blood, his arms placed on his belly, but his legs in an awkward position, with one leg firmly underneath the body. He had suffered 14 blows to the head, fracturing his skull and even making the brain visible. There were further minor injuries on the rest of his body. Gélis had locked up the night before and it was known he never let anyone in at night, unless he knew the person visiting. With no signs of a break-in, it is clear that Gélis let his murderer in – and was thus familiar with him. The murderer killed the priest, but

did not steal anything of value. Although cabinets had been gone through and some documents had been stolen, nothing of value, including 500 Francs, had been taken. Newspaper reports spoke of a "masked intruder" who had also broken into the presbytery many years before and had got away with certain papers. He was never found and now history was repeating itself and no-one was ever charged with the murder. Decades later, Saunière was mentioned by some as the suspect. Could Gélis be linked with the strange affairs of Saunière?

It is clear that on 23rd September, 1891, Gélis was one of three men visited by Saunière: the priest of Névian and (Ernest) Cros were the other two. But what is more intriguing is that the murderer had apparently left a small note behind in the presbytery of Coustaussa: "Viva Angelina". Long live Angelina. Angelina as in "A.A." or AGLA – Association Angelique? It might not seem much, but then, in a crime with no clear suspects, the smallest clues often have to do.

Villars wrote on the topic of "the great name of AGLA, which operates all these wonders, at the same time as it is called upon by the ignoramuses and the sinners, and who would do many more miracles in a Kabbalistic fashion".

Perhaps we should remember the word "sinners", as "pécheur" and "pêcheur" is another pun that might have attracted Saunière to his famous "Sot + Pecheur" reference, which no-one has so far been able to decode – despite various attempts from several "Saunierologists".

Gérard Moraux de Waldan contacted Lucienne Julien (of Narbonne) and George Cagger (Pumaz) several times, in connection with the coded texts of the mystery of Rennes-le-Château. Cagger went to the region of Isère for one or two private and discreet interviews with de Waldan. Although the majority of the decodings suggested by "Pumaz" have been published in the work "The Secret Societies with the Arrival of the Apocalypse", by Jean Robin, there is nothing on the text "Sot + Pecheur". On the information provided by "Pumaz", Moraux de Waldan stated that the name AGLA transformed itself into a simple reading grid. Could Saunière have had such a "trick" at his disposal? Everything seems to suggest he had, even though we do not know on which "grid" he was working during his "fishing expedition". Moraux de Waldan proposed that the grid was a simple system based both on writing and a phonetic cipher, constructed from the "pyramid". Moraux de Waldan thus believed that Saunière's text should be rendered as "invoked by the ignoramuses and the sinners", with "Sot" ignorant and "pécheur" sinner. If true, than this would echo the words of de Waldan, on how AGLA operated "great wonders". Nevertheless, such play on words is not evidence that would stand up in any court... even if, of course, that is exactly the reason why it was often used.

There is a long tradition of the "Green Language". It was Roger Facon who said, in summary, that for certain initiatory truths, the oral method was the only method deemed suitable for the majesty of the knowledge. With written documents the value of the truth that was reserved for a small number of people, conveyed from the mouth to the ear, depreciated. This is one of the primary reasons why archives of secret societies are very dull: they contain administrative documents, but not "the truth" itself.

One organisation known as AGLA was not esoteric at all. That AGLA was, from its inception, only intended to attract invited members from the publishing industry: booksellers, printers, etc. The presence of a Rabelais, Nicholas Flamel, Sebastien Greif, Montfaucon de Villars would therefore not seem odd – neither would the booksellers of Lyons, who bought Saunière's books. According to Robert Ambelain, AGLA also attracted the makers of the first sets of Tarot cards.

But Moraux de Waldan told us that the term AGLA had two different interpretations. Initially, it was indeed the name chosen for the corporation of publishers. In this case, the word is written "Agla", with a capital letter and the remainder of the word in small letters.

Then there is AGLA, but there is also A.G.L.A. – written with all capital letters punctuated by a point. In this interpretation, "AGLA" would not be one word, but the abbreviation of four words. It is clear that this approach would be a clever "trick" – a smokescreen. For all intents and purposes, any observer would read AGLA or A.G.L.A. as an incorrect rendering of Agla – a society which had no esoteric connections whatsoever. Even if someone felt that A.G.L.A. could not be an error, but meant something else, there was no way for that person to know

The famous cryptogramme

43

what each letter stood for – unless he had powerful computers at his disposal, or, more likely, came across someone who "knew".

If "Sot + Pecheur" was indeed "ignoramuses & sinners", it was such a safe code that few have been able to break it. If it was true, it suggests that somehow, Saunière was making an connection between himself and AGLA. And this would suggest that Saunière was indeed being "moved" by players.

So what might A.G.L.A. stand for? One proposed reading is Attâh, Gibbor, Leholâm, Adonâi: "Thou art strong for ever, O Lord". Actually, many people in Germany thought it stood for "Almachtiger Gott Losch Aus!"

It is said to contain all the letters of the Kaballah. Tradition has it that the Divine Power resides within this simple set of four letters, containing at the same time absolute knowledge, the science of Solomon and the Light of Abraham. In other readings, it is the Secret or Hidden Name of God, so cherished by the Kaballists, but also other esoteric traditions, including the Freemasons. The question arises, therefore, as to whether Saunière's remotely guided steps were to direct him into that direction?

Of course, it is easy to open up such avenues of "explanation" which never will nor could explain anything. So let us add that this interpretation comes from a document "Sot + Pecheur", written by de Waldan, and given to Déodat Roché and Lucienne Julien. It should therefore be made clear that this interpretation is different from the one that was presented by Gérard de Sède.

The word AGLA, in alphabetical numerical values, corresponds to this: A = 1, G = 4, L = 10. We do not repeat the second A, which allows a "loop reading" and which is at the same time the first and last letter of the "word". If we consider the "Sot + Pecheur", we find a "crown of letters" surrounding a rectangle containing the "text" in question. This crown of letters is made up of 22 characters, on the top and bottom, and 10 on the left and right-hand side. On the bottom and on the right, there is the only "AA" of the crown of letters. It can thus be regarded as the first and last letter of the closed loop of the crown of letters. Then on top, at 8 letters from the left and 12 of the right-hand side, one finds the group "GL". We will keep the number 22 in mind for the moment.

Now let us take the word AGLA and count how many times these letters are found in the text within the rectangle: (A = 8) + (G = 4) + (L = 10) equals 22. Moreover, while moving clockwise from the letter G, passing by L to arrive at A, we have 24+2 or 26, which is the exact number of letters of the alphabet.

However, to use a grid based on the letters of our alphabet, it is necessary to be able to work on the whole set of vowels and consonants of which it is made up. Let us remember that the "Société Agla" was strictly for the

book trade and for the first people reproducing the Tarot cards, of which the number of cards of the major arcana is... 22.

The whole of this knowledge could indeed therefore be reserved for those able to exploit the words, the letters... like the Tarot. Then by extension, and by similar pun, could it be used by those who could neither read nor write... but only spell?

When we say that "A.G.L.A." has an A at the start and end of the word, it is "A.A.", containing "G.L." Those who are aware of Masonic traditions will know that G.L. is often used as short-hand for "Grand Lodge", the Grand Orient. In pun, the Grand Lodge of Freemasonry is therefore contained within the A.A.

This may be a pun, but the A.A. is a genuine organisation – the very organisation, which was identified as the one to which Boudet and Billard belonged. However, trying to find information on the A.A. is next to impossible. Earlier on, we noted that a document was found, which listed Boudet and two bishops of Carcassonne as members of this organisation. This information was given to us by Gérard Moraux de Waldan.

It seems that several movements, at least four to our knowledge, claimed to be a part of this organisation. However, although it was certainly present in more than 39 areas of France, only the Toulouse area seems to have had retained documents on the subject.

The general presentation of these little known groups shows a structure established on secrecy, accompanied by an undeniable spiritual improvement. At the time of the French Revolution, these secret societies opposed a clergy managed by a civil Constitution. One also finds their virulent action against the Napoleonic Regime during the plundering of the Vatican archives, the general confusion in Rome and the arrest of the pope.

According to Jean-Claude Meyer, in the Ecclesiastical Bulletin of Literature, "The study of the AA of Toulouse, founded into the 17th century, forms part of the understanding of the more general movement of spiritual and apostolic reform of the clergy of France at that time. Beyond rules which appear out of date today, the history of this AA reveals the spirit of a sacerdotal fraternity lived by the fellow-members: thus is explained its exceptional longevity, one which will see the positive effects during the decade of the Revolution."

There is also the work of Count Bégouin who, in 1913, presented one of rare works on the subject in the form of a work entitled:

UNE SOCIETE SECRETE
EMULE DE LA COMPAGNIE DU SAINT-SACREMENT
—
L'AA DE TOULOUSE
AUX XVIIe et XVIIIe SIECLES
D'APRES DES DOCUMENTS INEDITS

A SECRET SOCIETY
EMULATING THE COMPANY OF THE SACRED SACRAMENT
—
THE AA OF TOULOUSE
FROM THE XXVII and XVIII CENTURY
ACCORDING TO UNPUBLISHED MANUSCRIPTS

On the bottom of the title page is the address of the "editors", set in two columns:
· on the left: "PARIS, Auguste Picard, rue Bonaparte 81"
· on the right-hand side: "TOULOUSE, Edouard Privat, rue des Arts, 14".
At the bottom of the last page of text (page 131), is the identity of the printer: "Toulouse, Imp. Douladoure - Privat, rue St Rome, 30–678."
Count Bégouin himself admits that there are difficulties when he tries to base his argument on previously unpublished documents, which are, of course, essential for his work. These documents were extremely difficult to find, although apparently some were said to exist in the region of Lyons and Vienna, at the beginning of this century.
The starting point of Bégouin's quest is the Parliamentary Decree of 13th December, 1660, marking the dissolution of the "Compagnie de St-Sacrement". It also stated that it was now forbidden "to all people to make any assemblies, neither brotherhoods, congregations or communities" anywhere in France "without the express permission of the King".
During the 17th century, the Compagnie de St Sacrement was a genuine movement which seems to have gone against the French King. It actually involved his mother, Anne of Austria, who seems to have plotted on the side of the conspirators, a group of people including Nicolas Pavillon, Vincent de Paul and, it seems, the Fouquet family. The statutes of the Compagnie stated that its sole goal was the "maintenance of the secret". But the French king came down hard on the organisation, and on any future attempt to reorganise it. However, it seems that the AA's original role was to perpetuate the Compagnie, to maintain "the secret" – and to make sure that this time, the powers that were, could not stop them.

AUX XVII° ET XVIII° SIÈCLES

L'AA CLÉRICALE

SON HISTOIRE – SES STATUTS – SES MYSTÈRES

Secretum prodere noli

A MYSTÉRIOPOLIS

Chez JEAN de L'ARCANE, libraire de la Société,

Rue des Trois-Cavernes, au Sigallon, dans l'arrière-boutique.

MDCCCXCIII

AVEC PERMISSION

Curiously, one of the first documents to use the term A and AA, was published by Mr. Lieutaud, a librarian in Marseilles. It was in the reproduction of a report of 1775, on the AA of that city, written by its president, with the complete order of what was known as a "Société". The title does not match up with the contents. It is curious that in a total of 16 pages, there is no reference to details of printing or the publisher. It is known as "A and AA, Preamble of a Future Encyclopaedia of Provence". It is difficult to understand the relationship between the AA and an encyclopaedia of Provence, however glorious its scenery is perceived to be. The same can be said of another booklet, again without any references, entitled "French history by a Carthusian monk". Two further works on the same topics would follow.

At this stage, two points demand our attention. First is the question as to how a librarian can publish books which lack all references; it is the very opposite of what his job description entails. Furthermore, as Bégouin himself stated, the titles are "odd and disconcerting". Any normal search in a library would fail to come up with these booklets, except for someone who knew what he was looking for.

But even stranger collections would be published: "A secret society of ecclesiastics in the seventeenth and eighteenth century - AA Cléricale - its history, its statutes, its mysteries", with the epigraph: 'Secretum prodere noli.' To Mysteriopolis, with Jean de l'Arcanne, librarian of the Company, rue des trois cavernes, at Sigalion, in the back of the shop. MDCCCXCIII - with permission." On the back of the page, it reads: "100 copies printed – none will be sold."

The reference is so enigmatic that you might suspect you had become a character in a detective novel! The "with permission" reference is just one in a long series of incredible details. Is it a hoax? A joke? Have these documents been falsified, as has been the case in some instances in the mystery of Rennes-le-Château? However, the booklet does exist and the reader will find that there is an accompanying document at the end of the collection.

Our librarian Lieutaud never betrayed his sources, except to state: "By ways that were both multiple and unexpected, the original parts that were used to compose this work fell into my hands. We are not authorised to say it, and thanks to God, though we never belonged to any AA, we know to maintain its secrecy."

There is little else, except some throwaway sentences: "Knowing how jealously the last owners took care of these invaluable papers, keeping them contained and hidden, allows me suppose that, as for the Company of the Blessed Sacrament, we are far from knowing all the places where these files lie."

On page 20, it explains that in Toulouse, it had access to the files of the AA, which had more than 1,300 names of ecclesiastics from the Toulouse region who were members.

This was not the only book of its kind. There was another such document printed in Lyons, at Baptiste de Ville, rue Mercière, in 1689. The book is extremely rare and unknown to bibliographers, just like yet another book, dated to 1654, which is intended "for a restricted number of initiates, those that belonged to the small group of elected officials comprising the AA".

The reason for the choice of AA or A.A. as the title is never explained in the documents. It is argued that it comes from the expression "Associatio Alicorum". Others say it comes from taking the two As from AssociAtion, and to present them in a similar way to those that appear in certain

alchemical writings such as AAA, for the term "AmAlgAmer", i.e. removing the consonants to keep only the vowels. If that were the case, such coding is contrary to Egyptian or Kabbalistic writings, where normally, the vowels are removed and the consonants kept, e.g. YHWH rather than Yahweh – which would be AE if the "vowel-retention cipher" had been used.

Bégouin himself believed that the AA should for "Amis" and "Assemblies", Assembled Friends, thus summarising the spirit of this company. Another assumption advanced by Lietaud is that AA stood for "Association Angelica" – the organisation which, according to some, was related to "AGLA".

One of the few letters sent by the AA does have the heading: J. M. J. A. C., which are the initials of: Jesus, Maria, Joseph, Angeli Custodes, i.e. Custodian Angels. This is an intriguing analysis. It seems to identify the AA somehow as being "Guardian Angels" of a "secret" that was at the heart of the Compagnie du Saint-Sacrement, and its successor, the AA. Perhaps the AA is the Association of Angels?

The rule of the "secret" was absolute and without exemption. Admittedly, for certain researchers within this framework, the "secret" was simply that of the "good deeds performed under religious initiative". But what is secret about "doing good"? If "good things" had to be kept secret, there are normally very good reasons for it – and the "good deeds" would not be of the everyday variety that you might do on weekends or weekday mornings in the church, those normally practised by elderly men and women, who are "doing good" for the community.

Instead, the AA says: "It is thus essential to maintain our secrecy. Reveal it to no-one, neither to the most intimate friends, nor to the dearest parents, not even to the most trustworthy confessor. Why would one speak with the confessor about it? In a project of this nature, that the only natural lights comes from the Father of Light, a similar confidence was never necessary; it would always be imprudent and often contrary to the existence or the propagation of our AA. Outside of the assemblies, the fellow-members will behave together as though no secret bond linked them. No sign, no word to make anyone suspect. In their letters, if they happen to mention the AA, it should only be in the shortest and most general terms possible. The AA will never be named, either in the letters, or in ordinary conversations. Those who have some papers relating to our Association on their premises, will preserve them with care and under key."

Surely this is not "just" so that no-one would know when the next cake stall is on – or what profit margin there was on the second hand books sale? These rules are similar to those of other secret societies, or societies, which require initiation. It could be that of a Masonic lodge, as they

49

could still be found at the beginning of the 20th century. But whereas the secrecy of a Masonic lodge these days is a matter of form, it seems clear that the AA is serious. The secrecy instilled in their members is more along the lines of an intelligence agency rather than a brotherhood of mutually interested individuals.

But the question is whether the AA is a secret society, or a discreet society. In the documents of the AA, the rules relating to the secret start from page 71 onwards. There is mention of a password, how to envisage the self-destruction of the cell, to destroy all traces of its existence, to pass from action to silence if there is the slightest doubt. You can wonder whether terrorist organisations practise such a level of secrecy. This type of moral convention is of such an inconceivable rigour that the only framework in which this document could come about is that of a fanatical sect... or of a movement that was elected to safeguard a frightening secret.

It is difficult to believe that within the Church, there would be a company, made up of monks, that could impose such injunctions to protect themselves if their only goal was prayers, benevolence or charity. After all, "doing good" has always been out in the open; "doing bad" is normally done in secret.

There is another intriguing aspect to the AA. Under certain conditions, it allowed the admission of women from exclusively female congregations. Furthermore, laymen could, under very strict conditions, be accepted too. According to the type of members, they were distributed over several "congregations". For the Seminarists, the AA rule envisaged a type of ante-room, called "Small Company". In this, the future priests were allowed to meet, without ever knowing the "active members" of the brotherhood. As in all other brotherhoods, there were several levels, or grades, in the hierarchy. No doubt, the lower echelons had no idea what the higher ranks were up to – as is the case in any hierarchical organisation, whether a business organisation or a secret society.

Even so, at this stage it is still possible to consider that we are talking about a congregation, though of a very exceptional severity, reserved for a kind of religious elite... yet without being able to accept or acknowledge that it could be something else – something more obscure – secret.

Yet, that this is the case, is argued by the document itself: "At the same time, behind this congregation or visible company, there was another occult one. It was the true AA, whose existence was a mystery and the name of the members an even greater mystery still. There were several political characters among them. The meetings were secret and certain members, in particular Prince de Polignac, only went to them in disguise.

For on being allowed into this association, it was necessary to swear to absolute secrecy, to promise a blind obedience with passwords which no-one else knew."

Prince Jules de Polignac (1780 - March 29, 1847) was a French statesman, who played a conspicuous part in the clerical and ultra-royalist reaction after the Revolution. If he attended such meetings, then it is clear that they were important – and controversial. If we place Saunière in the same environment, then we find a solid reason why he felt he could never divulge the origins of his income – not to his bishop, or to anyone else. He had sworn himself to it – to protect "the secret". Although it might seem bizarre that a small village priest should become a member of such a notorious organisation, he was a priest – somehow predisposed towards joining the AA – and a discovery in his church might have propelled him to the forefront of their attention – and their cash flow. It is clear that if Boudet and Billard were members of this organisation – and the evidence suggests they were – then they too would be part of this secret brotherhood. It would seem that de Beauséjour was not…

Although the AA is the best candidate for the framework in which Saunière and his closest allies operated, although membership of the AA could explain the extreme level of secrecy that Saunière adhered to – at the same time being instructed on how to maintain that secrecy so that his "double life" would never be known – it does not explain what Saunière and Co. were doing. What is still missing is an inroad into finding this out.

The AA has provided a solid starting point. It was a continuation of the Compagnie du St Sacrement, and that organisation, we know, worked with the Fouquet brothers, and was linked to the painter Poussin, Vincent de Paul, Nicolas Pavillon and others. However, it removes the timeframe from the 19th century and places it within the 17th century. Jumping slightly ahead in our investigation, it does nevertheless keep the main players close to Rennes-le-Chateau, more specifically in Notre-Dame-de-Marceille, where it seems the enigmas of the 19th century and the 17th century do overlap – and coincide.

Part 2

**The underground complex of
Notre-Dame-de-Marceille**

Chapter 7
On top of a hill

Notre-Dame-de-Marceille crowns a hill just outside Limoux, in the department of the Aude. The religious site is reached by a secondary road, number 129. It is a green, fertile, very active area, with an exceptionally rich history. It is also not very distant from St. Hilaire, whose priests possessed practically all of the Razès in the 11th century. Furthermore, it is assumed that Limoux was the capital of the Ràzes in Visigothic times, in the 5th century. Certain strange details would seem to consolidate this assumption, which would bestow upon the site of Marceille a more logical importance than that of "just" a place of pilgrimage, which is now its only claim to fame.

To begin with: a brief chronology. During the 8th century, there was only a modest chapel on this territory the freehold of which attached it to Pomas, a village located a short distance away. This freehold would came from the concessions granted to the abbey of Lagrasse firstly by Charlemagne, then by Charles the Bald and finally confirmed by Pippinus, the King of Aquitania. Towards 870, the freehold of Marceille was the property of Oliban, Count of Carcassonne. Around 1000 AD, the priests of St Hilaire obtained the site, ceded to them by Adélaïde and Roger, Count of Carcassonne, with the agreement of Pope Benedict VII (died ca. October 983). There are references to the vineyards of "Ste Marie", next to the "Villa of Flacian".

There is also the inventory of the possessions of the monastery of Alet, which lists Marceille, approved by Pope Callistus II (pope from 1st February, 1119 till his death on 13th December, 1124).

The abbey of St Hilaire had four "cellula", a kind of relay station on the way between the head office and Carcassonne in one direction, and Limoux in the other. "Marcillia" (Notre-Dame-de-Marceille) was one of these relays.

In the 11th century, this same freehold is found with Arnaud Siguinus, who, upon entering a religious life, gave it as a gift to the House of St Sepulchre. This is a house about which we know very little. Until this time, the grounds only seem to contain a small chapel or an oratory.

In 1214, we find the oldest reference to the "décimaire" (a habitat around a chapel) known as "Ste Marie de Marceille". A series of dwellings is mentioned in the files of Malta-Limoux in 1269. Finally, we should note a décimaire existing with the Order of the Temple of Douzens, in Marceille, towards the end of the 13th century. The order held 114 holdings out of the 272 on site – about half of the area therefore.

The front of the church of Notre-Dame-de-Marceille

Despite all the above, it is difficult to estimate the exact date on which the foundation of the church of Marceille took place. It seems that the church was erected following the miraculous discovery of a Black Madonna, found by a ploughman. His oxen refused to move and the man dug into the ground. He found the statue, which refused to be settled anywhere else other than on this site – even though our ploughman frequently tried to move it elsewhere. The religious authorities therefore decided that the construction of a significant place of worship on the exact spot of its discovery was the only option. The church of Notre-Dame-de-Marceille had thus justified its existence.

But one question needs to be posed: did the discovery of a small statue require such a large church – a basilica even? Also, if the Madonna was indeed found, who had deposited it there before? The circumstances of its discovery and subsequent installation seem to be rather excessive and so perhaps we should ask whether the basilica needed a legend that would "explain" – that is: explain away – its origins.

Whichever way round, the Black Madonna and the basilica are now connected with each other's fate; and therefore it needs to be pointed out that although there are several sites of Black Madonnas in France, Notre-Dame-de-Marceille is the only one in this region – making the site quite exceptional, but not so exceptional that it required a basilica to underline this fact.

When the Saracens threatened an invasion, the statue was quickly hidden – and its whereabouts apparently forgotten. However, it was later rediscovered, either by accident or divine intervention.

The Crusade against the Albigensians, also known as the Cathars, meant that this place had to be upgraded – it had to become a popular place

of worship. This meant that it was time for the Church to take control of the situation once again. The legend of the miraculous statue coincides perfectly with this revival.

Furthermore, bearing in mind the similarities of the site and tradition between Notre-Dame-de-Marceille and Notre-Dame-de-Laval, near Prades, perhaps it is possible that both churches and their annexes were completed at the same time: the 15th century. Both are also equipped with a Sacred Path, leading up the slope towards the church. Louis Fedié wrote: "Such is the short description of Notre-Dame de-Laval, built in 1433, and we find at Notre-Dame-de-Marceille the same architectonic conditions, but in much larger proportions. […] We can therefore establish the there was a great similarity between these two religious buildings, and [that] their foundation dates from the same time."

Anyone approaching Notre-Dame-de-Marceille by car today, will notice that its location is not apparently grand. From the direction of Limoux, it is a secondary road up the hill, with a sharp left-hand turn that eventually makes its way to St Hilaire. Were it not for the size of the church itself, it would easily be missed – when one compares it with the grand settings of other basilicas or "Notre Dame" churches, one would be justified in feeling cheated. However, this is how the modern traveller approaches the site. Standing in front of the church, facing it, to your left, right next to the road to Limoux, is a small pathway leading downwards. It might not have caught your attention, but it is the "original" road that the pilgrims used in their approach to the church. It is the "sacred road", paved with impressive stones, climbing step by step up the hill from the bridge across the river Aude – a river which therefore physically connects this site with the valley below Rennes-le-Château, through which the Aude flows. Legend has it that traditionally, pilgrims climbed the hill on their bare knees – their pain is easily imaginable.

The yearly festival and pilgrimage always occur on 8th September, celebrating the Nativity of the Virgin Mary. In the 17th century, the festival lasted a fortnight; in the 21st century, its duration is much more modest. In the old days, the pilgrimage had an incredible number of pilgrims, coming from cities and villages in the neighbourhood – and from even further afield. There were some who came from the Roussillon and the Ariège. It attests to the fact that the appeal of the festival was far bigger than it should have been in theory.

The pilgrim, climbing the hill, would note that almost at the top of the climb, on the right-hand side, was a spring, said to be a miraculous source for curing eye problems. Slightly lower is a stone slab, a monument dedicated to a "G. Vison".

Having reached the top, there is a small garden with the buildings of the Lazarist priests, whose mission is still active. The area was described by

the Belgian researcher Jos Bertaulet, whose work was published in English in 1994 by Philip Coppens. This lead to enquiries by Lynn Picknett & Clive Prince, then researching their new book, The Templar Revelation. In July 1995, Clive Prince visited the site with his brother Keith. When the latter had an accident nearby, Clive Prince ran towards this mission to ask for assistance. The Lazarists priests obliged – sending a cave rescue mission and the police, to help Keith Prince. We will return to this incident later. More recently, a fire broke out in their building, causing some damage.

The pilgrim would finally stand in front of the church and admire the porch: two doors, with a statue of the Virgin with the child Jesus in the middle. The statue looks modern – which it is not; it has been carefully restored. The doors still look impressive and show the old locks that secured the edifice.

Once inside, it is clear that this is a dark place – the image of a cave comes to mind. Whatever the weather outside – often brilliant sunshine – the inside is often too dark when contrasted with the outdoors. Nevertheless, the decoration of the building shows an accumulation of elements that attest to its history of being a popular pilgrimage site. A multitude of ex-votos testify to the enduring faith in the Virgin of Marceille. One relic attached to a wall is impressive: during an apparently well-attended mass, a piece of stone fell from the ceiling, hurtling to the floor. Amazingly, it missed all the worshippers – which they duly interpreted as a miracle, attributed to the Black Madonna. The stone hangs near her statue.

No longer visible in the church itself, but visible in ancient drawings of the church, is a spring: it used to be located on the opposite side of the entrance, in the nave. The water from the well was also considered to be miraculous. To the left of the nave is the object of worship: the Black Madonna, carefully encased if not almost shrouded from any visitor. This is the statue, which started it all… or is it?

Though it all started with the Black Madonna, is this one the true origin of the sacredness of this site? Modern publications do not show any evidence of any prior occupation, or identify the site as a sacred pagan site. Nevertheless, it is clear that the surrounding landscape, in fact Limoux in general, is rife with ancient, prehistoric remains, showing evidence of an ancient occupation of the region.

But despite this, Notre-Dame-de-Marceille seems to have no "prehistory". It almost suggests that the site was devoid of any occupation or interest for our ancient ancestors. This in itself would make it remarkable – specifically when it is widely known and agreed that most Christian religious sites were originally pagan places of worship.

It has to be said that the site would be deemed to be of "category one"

The presence of a well, no longer present in the current building, but visible in this ancient drawing of the interior of the church

for our ancestors from a religious perspective: located on hill near a river, it is a key site for early settlement. Still, it seems there are no remains from this era, even though archaeological collectors, amateurs, from Limoux, Narbonne, Esperaza and Couiza still retain many beautiful collections from the surroundings of Notre-Dame-de-Marceille and St Polycarpe, attesting to the fact that the area definitely was settled in Neolithic times.

The only light on this enigma seems to come from the notes of a priest, known as Ancé. We have very little information about this man; we do not even know his Christian name. The only thing we do know is that he was of fragile health and stayed in the Limoux area, for a period of at least two years. It seems that during this time, he had no specific religious tasks to perform. So he attended the meetings of Professor Bertain Louis de Polla, who originated from Montpellier, who familiarised him with the area around Carcassonne. Both men shared a passion for archaeological research.

Ancé gathered his information around 1865 and it was thanks to his heirs that we came across his information. His accounts were written down in little booklets, only one of which remained. The priest had carefully – scrupulously – written down what the local farmers and vine growers had shown him: objects, bones, etc. It seems that this information was later consulted by G. Sicard, who was involved in the official archaeological inventories of the department later in the 19th century.

Thanks to Ancé and de Polla, we know that there were definitely remains from the Bronze Age, specifically burials. Furthermore, there were remains

from the Merovingian area, near the church itself. All these discoveries were made accidentally, during farming or forest clearings, mostly along the areas bordering the church grounds.

When reading the Ancé notes, it seems that he suggested that all the Merovingian graves were located in pre-existing Bronze Age funerary pits. This in itself is intriguing. The tombs were oriented towards the setting sun – the west. According to the same reports, the bones that were found in the tombs were fairly well preserved. Most of them were human skeletons. Those remains which still had the cranium showed evidence of ritual trepanation, a ritual in which a hole in the skull is made to facilitate the departure of the soul from the body. Three bodies were said to be without the cranium, two of which were male skeletons. The bodies were accompanied by funerary deposits: pins, engraved metals (often clothing fasteners), though apparently not much jewellery or other ornaments. Nevertheless, one body was said to have had beautiful offerings, apparently quite unique for the area.

The priest's notes state that some weapons were found, but not many; curiously, they were all placed on the outside, opposite the tombs. Burial with the weapons away from the deceased is practically unknown in the area – in fact, nothing similar exists.

One of the tombs sheltered the remains of a woman, who was buried with those of a young child, whose cranium was missing. Finally, one body, that of a man, had a mutilated right hand, which missing from the tomb. The amputation seemed to have been the result of a brutal attack. These are not the only documents on file. There were other documents, notes and especially references, such as bibliographical sources, which enabled Ancé to consult documents that were not indexed as religious material. He quotes one such source as being a folder of various documents, in a very bad condition, apparently recovered by an inhabitant of Limoux when the roofs of a house in Notre-Dame-de-Marceille were being cleaned. These documents seemed to be disparate, incomplete and not indexed – it seems they were never made available to the bishop's archivist or the local historians.

The body of documentation suggests that the Church's intervention on the site, specifically by the Dominicans, put an end to all historical references – in particular, it seems to have created an absence of details on the site's past.

From this material, we learn that the pre-Roman structure was a kind of grand, enclosed funerary oratory, from which all extensions of the building originated. Another document, from the end of the 16th century, refers to several Latin documents, in a state of great deterioration, unknown to the religious authorities and thus backing the statements made by Ancé. These ancient accounts state that close to the top of the hill, there was a

megalith, inclined and with a narrow, buried cavity, close to which a small primitive cemetery extended. The entire site was apparently carefully respected and maintained until the end of the 6th century, the Merovingian era. It seems that at that time, the site was extended and this meant that the megalith was destroyed; the cavity itself was most likely filled in. Apparently, inside the cavity was an ancient image, highly venerated, and cut into the stone. It seems that the Church decided to remove the megalith itself; the engraved stones were apparently fitted into the stones around the sacred spring.

Ancé states that he tried to get more information on this episode from the archives of the bishopric. It seems that the reply he received was a request to stop asking for further details and waste time on vain research: "where there was nothing, and maintaining furthermore there was anything to find, where it would be misplaced to try to follow a past closed forever, composed at most of some thin vestiges of prehistory and paganism, incompatible with the history of our Holy Mother the Church."

However, while he submitted by obeying this council, Ancé still noted what he could, but would not publish it or share it. Instead, the documents would have disappeared forever and nobody would have found a trace of them – had it not been for his heirs, who kept his documents. As a result, the archivist of the bishopric in Carcassonne would never have been able to point out the existence of these documents to us – officially, they were never aware of them.

The origins of the pagan, megalithic sanctuary that preceded the Christian site of pilgrimage will most likely never be clearly identified. The re-used Merovingian tombs seem to be the best available evidence that something of a sacred nature was there. Nevertheless, it is now possible to locate the original site of the pagan sanctuary – near the miraculous well. It is perhaps why the Church decided not to remove the sacred spring from its premises for a very long time. Still, it has to be pointed out that for any modern visitor – of which there are many, especially after the publicity received from the works of Bertaulet and Picknett & Prince – nothing of specific interest would be visible. Today, the Church has made sure all evidence of its pagan past has been removed.

Finally, we should note that it is in the notes of Ancé that other writers, first F. Sauvère and later G. Sicard, would find the interesting legend of the standing stone on the site of St Polycarpe: "one day a giant named Marre played with this stone which he had, it is said, torn off from a chain of rocks known as 'La Roquo Broundo', close to St Polycarpe. He wanted to throw it like a metal disc on Alet-les-Bains. But he launched it too short and the stone fell where it is today. The giant looked for it for

a long time because he had printed his fingers deeply into the rock mass." Ancé stated that the area was rich in cut stone axes. Furthermore, he also mentioned the standing stone at "Peyrolles", near Arques, near the residence of "Mr Laurence". What is intriguing, however, is that Ancé writes that at Peyrolles, "within the area of Pontils" as he himself pointed out, there was a legend of a cave near the megalith. Ancé added that he himself had not been able to verify the story himself. Nevertheless, it is obvious that he drew a clear parallel between St Polycarpe and Peyrolles, between the area of Notre-Dame-de-Marceille and Arques – the general area of Saunière and his associates.

Chapter 8
From "Ste Marie" to Notre-Dame-de-Marceille

It is almost certain that the name of Notre-Dame-de-Marceille has changed over the centuries, as happens so often with toponyms. Sometimes, this is merely a change in the spelling, but there are also changes from an etymological perspective, depending on which logical or historical origins are changed dramatically – if not actually obscured.

At present, we know the place as "Notre-Dame-de-Marceille". The first component is straightforward: it refers to the Virgin Mary. There are many sanctuaries dedicated to the Virgin, and hence this place follows the general rule, which is to identify it more specifically, in this case "de Marceille". We know that the "Virgin part" of the name was originally "Holy Marie", or "Ste Marie". It does not seem to have been a major change, but then you also wonder why the change occurred at all.

The deeds of donation from the Count of Carcassonne, Roger I, date from 1011 and they mention a vineyard located in a place known as "Ste Marie". In this act, there is no mention of "Marceille": "in villa quaevocatur Limosus... in vineale Sanctae Mariae." This document, which is the deeds to the site in favour of the abbey of St Hilaire, is one of the oldest documents mentioning the site.

We have to wait until the 13th century to find more evidence, this time in the form of people living in the area: Carbonnel de Marceille, Raymond Fabre de Marceille... It is clear that the site is now known as Marceille. The oldest reference to the name "St Marie de Marceille" stems from 1277. This is in a religious act from Prouille: "Sancta Maria de Marcellano." This name, of course, goes against the accepted assumption that originally, the name was that of "St Marie". The name suggests the site was originally known as "Marceille" or "Marcellano" – which would seem perfectly logical if one were to assume pre-Christian – pagan – origins. Evidence that this is indeed the case comes from a Latin text, dating from the Visigothic period, in which there is mention of a "Marcelli forum", an open area of Marceille.

In fact, it seems that the name comes from the Roman era, when there was a "Marcellanum", the "ground of Marcellus". It seems Marcellus was the first owner of this site. So who was this person? One assumption is that he was one of Caesar's military advisers, installed in this sector as a reward for his glorious contributions to the Roman armies, specifically the 10th legion. This derivation would assume that the name Marcellus was corrupted to Marcellum and then to Marceille: straightforward and in general a name that does not seem to have strayed too much from its

original meaning.

There is, however, a second possibility. This one is much less known and more difficult to validate. It also states that the 10th legion was involved, as it was stationed in the area. Following a battle, a Roman officer, named Marcellus, was allegedly seriously wounded, and brought back under an escort. Back at camp, he would receive medical attention, specifically it might have been possible to save his life by performing certain amputations. But apparently the man was too seriously injured and succumbed to his wounds shortly before arriving back at camp, and his fellow soldiers decided to bury him on the spot where he died – as was their custom. To remember him and the battle, they named the place after their officer. It seems, therefore, that Marcellus passed away, not while doing good, but dying in battle. But rather than jest, this story has further intriguing components. The officer had apparently crossed the river close to a hill on top of which was a small oratory dedicated to Mars, the Roman god of war. This would identify the site of Notre-Dame-de-Marceille as a Roman sanctuary, an oratory. Farfetched? It is a fact that Limoux was built on seven hills, mimicking Rome. The Romans referred to Limoux as Flacianum, which would remain the most significant city of the Razès until the 13th century. Are we to believe that only atheist Romans lived in this town and that hence there are definitely no Roman sacred sites in the area? It seems more logical to suggest that there were indeed Roman sanctuaries, and that because this was a Roman – pagan – site, the Church has tried to suppress general awareness of the site's pagan origins ever since, as is clear in the reply Ancé received from his superiors.

Mars has become associated with war – male dominance. But originally, he did not symbolise war and combat; instead, he was the guardian of vegetation and culture. This might contribute to an understanding of "Marceille", a name which obviously has "Mars" in it; a region which is known from prehistoric times for its settlements and to this day, as a site of vine growing – the grapes for the famous Blanquette de Limoux, the predecessor of champagne, are still grown and worked all around Limoux.

In Rome, the priests who served the god Mars normally came from the college of the "Salians". In French, this word has an instant link with salt, salted or even concealment. But apart from such puns, it is known that the Salians were very powerful in the Languedoc, where they were regarded as excellent advisers. If there was a sanctuary of Mars here, it seems likely that there were Roman priests – advisors – in residence there. Of course, if this is the case, then the modern presence of Lazarist priests serving the basilica is history repeating itself.

The attributes of the god Mars are the shield, the lance, the helmet and

the wolf. Furthermore, if a Roman legionnaire was indeed buried here, custom would have it that Marcellus was buried together with his lance, his shield, helmet and any trophies of war. We see, therefore, that, to a large extent, Marcellus and the god of war overlap – and one can only wonder whether Marcellus was interred there because he was a legionnaire, and because the site was dedicated to the god of war. As to the symbol of the wolf: one of the side chapels of the basilica is dedicated to St Loup – the wolf.

Furthermore, the legend of our legionnaire is still not yet exhausted. It continues that his fellow soldiers were unable to close the eyes of the dead Marcellus. His glance, in death, remained sharp. It is clear that this cannot be a coincidence when we note that Notre-Dame-de-Marceille was known for its "miraculous spring", which was said to cure ailments of the eyes! If it is a coincidence, it is an extremely remarkable one!

Both Mars and Marcellus were male – that is obvious. It links the site with war, male testosterone – perhaps even running wild. The name was then transformed to Marceille, and now it is decidedly feminine: Notre Dame – Our Lady. It is no wonder that its pre-Christian past is so difficult to grasp when even the "gender" of the site has been changed.

But in spite of its feminine connotations, the site is still markedly male. It is run by Lazarists, an organisation from the 17th century, created by Vincent de Paul, whose statue still stands in the garden opposite the church. In fact we might have expected a nunnery. Despite the disappearance of the original cave, the interior of the church is still very dark – almost subterranean, and well, cave-like. Somehow, the place remains an enigma.

So how did the site ever become feminine? Definitely a long journey when the site was connected not with just any male deity, but with the archetypal male deity – Mars. It came about by first adding "St Marie" to the name, which would itself be replaced later by "Our Lady". Thus it is also clear which Mary was referred to: the Virgin Mary, the mother of Jesus. There are other candidates in the Bible named Mary, such as Mary Magdalene, but these do not seem to have a place here. Still, that is not all. It is now assumed that sites now known as "Notre Dame" were usually so named in order to try to obscure the fact that the site was originally a pagan sanctuary that had been Christianised, by replacing the original god with the Virgin Mary. It seems that this is indeed the case here.

However, evidence of a pagan past was difficult to live with – and normally required a miracle. These miracles usually took the form of, well, a miracle: an animal, whether ox, cow, dog, horse, bird or wild boar, chanced upon "something" miraculous, but a clearly Christian symbol – a statue of a Virgin for example. Surely this was proof of the fact that

the site was Christianised? Often, the discovery was that of a lady, with a baby – Jesus – in her lap. Often, the lady was black-skinned. So it was with the case of Notre-Dame-de-Marceille, but in so many other places as well, including the famous Notre-Dame-de-Chartres, where one of the greatest cathedrals would be built in honour of the Mother of God. If truly miraculous, it seems that either the Virgin, Jesus or God had an abundance of these statues and scattered them not only across France, but across most parts of Western Europe – and even further abroad. A more likely explanation is that the statue was the "deus ex machina" employed by the Church to prove that it could now rightfully lay claim to the site, which the old deities no longer ruled; Christ did.

Chapter 9
The strange Black Madonna

"The history of our pilgrimage is lost in the continuation of the centuries. We could not assign a date, nor an original description to the object of the first prayers of the faithful." This is what Mgr Beauséjour – Saunière's nemesis – wrote in August 1912 about the statue of Notre-Dame-de-Marceille.

It is clear that the statue was at the origin of Christian worship at Notre-Dame-de-Marceille. It is also clear that this veneration is very old – no-one questions the extreme age of the statue that is still venerated in the basilica. Where it was originally placed, is the subject of some debate. Some seem to suggest it was in or near the miraculous spring, others speak of an underground chapel.

The story of its discovery has already been recorded, but we will repeat it here once again: "At one time, in the quite remote past, a ploughman who cultivated his field on the slope of Marcellan saw his ox stop, as if halted by an invisible obstacle. He pushed it in vain, to urge it on, but it stood stock-still and resisted every prodding. The ploughman, who was amazed at first, suddenly felt the only other thing he could do was to call to Heaven for help. Then, somehow inspired by this plea for divine assistance, he began to dig the ground where the ox had stopped, only to find that it contained a statue. It was that of a wooden Madonna, brown and dark, with a celestial smile on her face. With great respect, he took the statue to the door of his house, where everyone in his family rejoiced at the sight of it. But their joy was short-lived: the following morning, the Madonna had disappeared. The ploughman returned to his field, and found the image in the place where he had discovered it the day before. Again, he rejoiced and carried it home, but in vain. It returned once again to the place where he had found it. He tried a third time, but to no avail. The stature returned to its hole in the ground."

The news of the discovery apparently spread very quickly. The local monks recognised this intervention as divine will… and, according to the tradition, they built the first chapel there, to house the statue. Apparently, this story was depicted in a painting, on display until 1793, when it was lost during the upheavals of the French Revolution.

What does the statue look like? One description was made on 15th August, 1912, at the request of Mgr de Beauséjour, the bishop of Carcassonne: "We wanted to study this statue, without the gilded coat which wraps it, in order to identify it conclusively. We were surrounded by qualified people and we believe we can affirm that it goes up back to the eleventh or the twelfth century.

"It is a virgin, made of wood (height 55cm, excluding base), sitting on an armchair of which there are only the frailest remains. She wears an evening gown, covered by a full coat, which still has its collar and is fastened all round by staples. The head of the virgin is surmounted by a wooden circle, the circular base of a crown, from which the florets have disappeared. This crown still has a veil, which falls onto the shoulders of the virgin, and covers the higher part of the coat. The Mother, on her left arm, holds the child Jesus, sitting on her knee, whose mutilated hands held an object now worm-eaten, perhaps a bird, which is so often the case.

"The folds of the dress, the pointed shape of the sandals, the presence of the crown, that of the veil which is somewhat detached, the attitude and the general aspect of the statue, all indicate that in spite of the many mutilations and the passing of time, the virgin stems from the era we have indicated above."

Thus history and legend meet. However, the tradition has it that this wooden statue was created to replace another statue, which was much older and the source of many more legends and rumours. This "much older" image was the carved stone, venerated in the megalithic complex that originally stood on the site. However, unless there are some remains left in the miraculous spring, which has now been built over, there is no way for us to know the truth about the carving or the details of what it showed.

To this, we need to add that often in times of war or social turmoil, religious or historical treasures are often secreted in hiding places, often underground. After some time, their exact hiding place is often forgotten, and the original treasure is replaced with a more recent reproduction.

In the case of Notre-Dame-de-Marceille, we need to consider whether in this scenario, the hiding place was a hastily dug pit, the exact location of which was consequently lost – either by design or accident – or whether it was safely placed in an underground complex, the existence of which was known to only a handful of people. In the latter scenario, revealing

the existence of the underground complex might not have agreed well with those who knew all about it, and hence the statue might have been moved, or a legend created as to how the statue was rediscovered. Is this idle speculation? It might seem that way at the moment, but wait... The above discussion of the substitution is not idle chatter. The issue was raised by Mgr. de Rébé, who included a very significant and enigmatic detail in a confidential letter addressed to a correspondent whose function was carefully excluded. We found reference to the document in a letter of 21st July, 1641, in the files of Allan Marquis de Saves, also published in the annals of Maurice Mout in 1755 – Toulouse, (collection Jonet and Sauche).

These documents and logic suggest that it was not divine intervention, but a carefully planned out project. Playing devil's advocate for the moment, we should state that if the statue had been there for a long time, and it was indeed Divine Intervention, why the ox had not stopped there earlier? Idle speculation again, but given the extra-ordinary circumstances of the "official story", is the that version likely? More likely, our ploughman would be part of a plan, to identify his field as the setting for a "divine intervention". If the purpose of the project was to build a shelter for the statue, than the ploughmen might have been given money in return for his loss of income.

But there might be more to this than just an exchange of property for money. The field might actually have been located on top of an underground complex, which obviously must have had an access. The building could therefore be built on top of this underground complex, to guarantee that access to the complex was strictly regulated – or cut off. Thus, the quick erection of the building would make sure that the existence of the underground complex remained a carefully guarded secret. Obviously, if anyone knew of such an entrance, it would be our ploughman – after all, he spent most of his time in the area, and would notice any strange rocks or cavities in or near his field. Once the shelter was in place, there would no longer be any possibility that anyone might accidentally stumble across the access to the underground complex.

Mgr de Rébé visited Notre-Dame-de-Marceille. It has to be said that the bishop's coming was justified from the point of view that he seemed to be carrying out certain checks, inspecting certain details that apparently could only be performed on site. His report reads that during his visit, he was able to discover elements that seemed to reveal to him what was there, and which should not be revealed to the public at large at any cost. This meant that three statues had to be removed from the site, as they were not "decent". But that is not all. The three images were not destroyed – their fate was contrary of that of the Black Madonna: they were put into a hole in the ground, to be forgotten. Note that de Rébé

69

states specifically they should not be destroyed, but buried. It suggests he either knew their value, or respected it – and though he did not want them to be revealed publicly, neither did he want them to be destroyed. But there is another question: why did he not remove them from the area of Notre-Dame-de-Marceille, take them somewhere else? Furthermore, what was so indecent about these statues? Although a devout Catholic might have been surprised to learn that Christian churches were built on pagan sites, de Rébé and many others knew their history and were familiar with how "indecent", pagan statues were often found near churches – evidence of their former use. Still, either de Rébé had great respect for the pagan origins of these sites, or somehow these statues were more important than most. Perhaps de Rébé was more "pagan" than Christian: he had to follow orders and make sure the statues were not discovered again, but at the same time they would remain on site, to "paganly empower" the Christian sanctuary.

Another dignitary of the Church, Mgr. de Grignan, applied the same technique. He also discovered stone statues and decided to rebury them. This practice is bizarre. It is as if the statues are indeed important, but at the same time revealing. Taking them elsewhere might have resulted in more questions – or observations from certain people with some knowledge, who might not be allowed to "know". It seems as if the statues had to be "retained", as if they would have some future purpose; literally, it feels as if they were important, but that their accidental discovery was not at the right time – which was deemed to be "later".

In theory, this means that from the 17th century onward, the area around the basilica was a discovery waiting to happen: any ploughman or gardener would, given he was working on the right location, be able to chance upon such statues or other finds. Perhaps it would indeed be another "miraculous discovery". This in itself does not make sense. And perhaps when they say "reburied" there is a bit more logic to it than assumed. If there is indeed an underground complex, perhaps they were "buried" in the sense of being stored there. That way, their future use – and preservation – would be less down to luck, and more down to logic – and intelligent design. In this scenario, some people would be in the know, others would not. Perhaps this could explain the ensuing frenzy in the centuries afterwards when various dignitaries would fall over themselves to acquire Notre-Dame-de-Marceille. Perhaps their intention was that, once in their possession, they would be able to recover this valuable archaeological deposit stashed away in an underground complex.

But let us continue with the story of the Black Madonna. She displays some remarkable details, for those with eyes to see them. After all, the spring is said to benefit eyesight. The most striking aspect of the statue is

its face. It has an enigmatic smile, its eyes are wide open, with dark pupils, which seem to scan the visitor. According to an old inscription, it stated that he "who sees the statue smiling at him, is certain to obtain the grace which he came to beseech".

Reading through the various works on the subject, one detail seems to have escaped all authors: although the virgin is indeed black, the child Jesus is not; it is white. This might not be remarkable on first reading, but it is obvious that if the Virgin Mary was indeed black, then a totally white child would be – at the very least – an oddity. It is clear that some symbolic layer is at work here. Perhaps it was to express how the Black Madonna – dark symbolising the obscure, the underground – had somehow been the source of a light, solar child. Darkness would give birth to light. This in itself is pagan imagery: in Greece, Crete to be specific, the god Zeus was said to have been born in a cave. We know of Newgrange, where the sun penetrates the darkness of the passage grave on 21st December, the longest night of the year. The interplay of light entering the darkness, and being born from it, is a well-known pagan symbol. And with the presence of a megalithic complex on this site, we can only wonder whether this subtle hint had to incorporate that same message.

A final oddity of the statue is that most often, the object of worship in a church is prominently displayed. In this instance, the statue is almost hidden in the church – shielded by a railing that obscures the view. But that is not all. Apparently, the niche sheltering the virgin originally had an inscription: "Do not look at me, because I became brown." The existence of this inscription is mentioned in a document known as the "Homage to Baron Podenas". Here, someone has stated that the statue should not be looked at. "Avert your eyes." It also makes you wonder about the use of the verb "to become": it suggests that originally, the statue was not brown.

Speculation on the two parts of the sentence could be endless, but some is interesting. For example, was the inscription added at the moment when a switch occurred, when the original stone statue had been lost, and the new wooden statue of a Black Madonna installed? Were people asked to avert their eyes from this reproduction, as it was somehow not the real deal? Still, it is clear that few have paid attention to this detail; apart from the above homage, no-one else seems to have referred to it. We know that in the early 20th century, experts identified the age of the statue as dating from the 11th or 12th century. But it did not always reside inside the church during that time. In fact, it was removed at the time of the French Revolution – but unlike the previously mentioned painting, it was recovered. On 1st February, 1791, an inventory was made of the goods of Notre-Dame-de-Marceille. It was the first in a long

71

process of further inventories, seizures, sales and in general a degradation of the wealth of the estate. Another official report, dated 20th July, 1793, lists an inventory of everything that is in the church, including the Black Madonna. But then it disappears. It is reported "stolen". But it is noted that the doors were not broken into, nor were any of the windows smashed. Was it a miraculous disappearance, on par with her miraculous appearance centuries earlier?

On 25th July, 1793, the police chief was given the task of carrying out an investigation into the disappearance. He turned up nothing. On 30th July, the national agent of Limoux drew up another report, with a complaint against "an unknown young woman who took advantage of the moment when a census of the church's effects was made, to remove the statue". So it seems an unknown woman somehow was either involved in the census, or managed to get in, and stole the statue. But there was no trace of her, or the statue. No-one seemed to know her, even though apparently one or more people saw her take it. The agent seems to have been extremely frustrated when taking statements, as he mentions in his report how people speak of a miracle. It suggests that our officer might have suspected the witnesses were not telling everything and that he was suspicious of them. Also, it is clear that the Revolution had seriously harmed the power of the churches and in essence had made them "accessible" to the police. Our officer was working "on the edge", putting church affaires under civilian scrutiny – a novelty for those days, and fraught with the danger of stepping on the wrong toes, or angering the people involved.

Nevertheless, or perhaps with renewed vigour, the agent continued his investigation. He then learned that the statue was not stolen in July, but had actually disappeared on 29th June – suggesting the official census of the church's goods carried out on 20th July was falsified – or at the very least incorrect. It did underline that his witnesses were lying to him. What is even more perplexing is that the agent learns that on the day of the theft, the church was guarded and that no-one would thus have been able to force open the doors – unless the officer guarding the premises was involved in the disappearance and aided entry. Obviously, the agent has more questions than answers: what to make of the mysterious woman, and also what to make of how the thieves entered the premises, if not aided by the guard?

The report mentions an intriguing detail; a strange detail. It reports how in the field next to the church, there suddenly appeared, as if rising from the ground, a strange young woman, dressed in black. She fled, running, apparently holding onto the statue of the Madonna. This would be remarkable, as the statue is quite heavy. The guard was said to have run after her, but in vain. Not that she outran the guard, but because suddenly,

he no longer saw her or the statue. It was as if the ground had swallowed her up…

On 8th August, the Revolutionary Committee of Limoux was summoned, together with the municipal council and the national agent of Pieusse. Apparently, this disappearance was of great concern to them, specifically as it affected their newly acquired status in the community. It seems that the inhabitants were more and more worried about its disappearance. To some extent, one should perhaps wonder whether the theft was orchestrated so as to cause a loss of face and esteem to the new Revolutionary officials – who after all had done away with the power and esteem of the Church… the bailiwick of the Black Madonna.

Whoever was behind the theft and whatever the motive, it is known that rumours began to circulate about how a group of unknown people began to move around at night on the grounds of Notre-Dame-de-Marceille. Furthermore, like the woman before them, they seemed to "disappear". This would soon lead to rumours that an underground complex had been discovered where hidden treasures were buried, said to have been entrusted by rich local aristocrats, with people descending on the place from… no-one knew where they came from. If these were indeed strangers, they were definitely intimately aware of the area and specifically of the underground complex. Furthermore, it seems that somehow, there was a connection from this complex to the inside of the church – used by the thief of the Black Madonna. Although no-one knew who these people were, it seems that they all shared one characteristic: they were dressed in black. Although it would not help any police investigation, it does show their actions were organised.

In order to calm the situation, the revolutionary committee made a formal complaint against the overseers of the church on 21st June, 1794, stating they had removed the statue. This complaint, however, was never followed up.

Wherever she was hiding, we do know that the Madonna turned up: in the trunk of François Lasserre, former regional prior of the Blue Penitents. As to the identity of the young woman, nothing would ever be heard about her. Nor would there ever be any trace of the group of individuals that somehow seemed perfectly knowledgeable about the old underpasses of Notre-Dame-de-Marceille. What was going on here? It is clear that the witnesses had lied to the police, and that the police therefore charged them. But soon after this charge, the statue was recovered, and no further legal action was ever taken. It seems likely the members of the church itself had been responsible for the removal of the Madonna and when pressed by the police, became so afraid that they decided to stop their activities and give the Madonna back to the community. Why? Why steal, or rather hide, it in the first place? Good questions…

After the Revolution, the statue would be returned in time for the reopening of the church, on 8th March, 1795. G. Migault wrote on the subject: "This episode of the removal of the statue is curious, almost like a detective novel; it is, however, brought back to us in all the letters, in the official reports of the national agents." Indeed. But it also shows that at the time of the French Revolution, two hundred years ago, there was definitely still an underground complex near the church, with a group of people aware of it – and making use of it. Furthermore, one would suggest that the complex still exists today…

Chapter 10
A vault under Notre-Dame-de-Marceille

Whether or not there were underground tunnels or vaults under the basilica is a question that has been posed periodically. The theft of the Black Madonna and the accompanying sudden disappearances would seem to prove that the answer is a definitive yes. But such a "complex" need not necessarily be complex: a simple gallery would suffice. But the antiquity of the site might suggest that there is more to it than meets the eye.

It is possible that the underground complex dates from prehistoric or Roman times, connected to the original sacred site. Alternatively, it might be more recent, built at a time of war, which would require a system of evacuation, of supply, which would make the entire complex more effective, but also more discreet. Which option to go for? The former suggestion seems more logical, as it is, after all, a religious site. It is known that most religious buildings – churches – were built on places where there used to be crypts, often reverently preserved by the project engineers in charge of the new building project.

Furthermore, it is known that in any building project, specifically the enlargements of buildings, some parts of the complex, e.g. underground vaults, become disused – and are forgotten about. This could be compared to the miles of disused underground tunnels and stations of the London Underground – or similar systems in other cities.

Where does Notre-Dame-de-Marceille sit within all this? It should be noted that no literature mentions the existence of the complex. Occasionally, some authors add that there might be "something" under the basilica and the surrounding grounds... but nothing direct or precise is ever stated. It is as if the subject is forbidden – as Ancé seems to have found out when he asked the bishopric for details. And if so, the question as to why is most important and intriguing.

R.P. Migault writes that "the 17th century gives us the name of a hermit, Antoine Daude. This hermit was witness to a marriage contract, dated 3rd November 1611, between two people of Limoux. As he is known 'to have known the parts well', before embracing the lifestyle of the hermit, he had obviously lived in Limoux, from where perhaps he originated. He received the habit of the hermit from the hands of Mgr de Vervins around 1610. He died around the age of 80, and was buried on 17th September 1656, in the church of Notre-Dame-de-Marceille." Hermits normally live alone, but also in a cave. Did this man live in the underground complex? The fact of the matter is that no specific details are given as to where exactly this man lived.

But at least it is known that he was buried there. It is, of course, nothing special to be buried in a church; some churches are full of paving slabs that double as tombstones. In this regard, let us add that the floor of the church was originally made from boulders from the river Aude, at the bottom of the hill. These were quickly replaced, for obvious practical purposes, by stone slabs. But there is no mention of the existence of tombstones in the nave – and of no specific individuals interred there. In fact, apart from our hermit, there seems to be no specific record of any burials allowed here by the Church!

Let us also note that the ancient well seems to have been the focal point of all funerary activity, until the beginning of the Middle Ages, when it seems the well either dried up, or was lost when the nave of the church was enlarged – or during other modifications to the building. It would appear that nobody was interred here afterwards. But no doubt, requests for burials must have been received – and it would seem, therefore, that they were declined. This would suggest that someone in authority had the power and desire to decline such requests, and did so, even when notable people requested to be buried there. Why?

The first possibility could be largely due to simple material and technical reasons: ground water that might invade the tombs, resulting in moisture or pollution, if not poisoning of nearby springs. But this argument does not hold water, as the miraculous spring is only eight metres away from the church and its water seems perfectly fine. Furthermore, it is known that the first inhabitants made a ritual perimeter around the spring to dig funerary pits there. These burials seem to have continued into the era of the Romans, a people who had specific knowledge of hydraulic systems and water quality. If the water was harmful for human purposes, they would surely have put a stop to it. And after the Romans, the Merovingians continued this practice. Furthermore, the construction of a basement would not create any such problems: a basement would be ideal for tombs, as is in evidence in so many other churches.

Another disadvantage of not pursuing a policy of interment was that the Church missed out on income – something it was always loath to do. It is clear that selling space for the tombs of the deceased nobles of the area was a lucrative endeavour, if only because it was accompanied by subsidies in the form of saying prayers, masses and offerings for the deceased on an annual basis.

But Notre-Dame-de-Marceille definitely has missed out on that trade. The reason why should therefore be sought in other directions – taking us into an area where proof is more difficult – if not impossible – to gather. But in line with other assumptions, let us perhaps come up with the most straightforward answer: if the church was indeed built to seal off access to an underground complex, any burials in the church would,

by default, open this complex up. Burials would therefore defeat the original purpose of the building – hence no burials would be allowed. Let us further observe that only the span of the right-hand side of the nave comprises side chapels. The left-hand side is rectilinear and without any extensions apart from chapel of the Black Madonna. It is on this side that the well, the Madonna and the sacristy are situated. But it is unlikely that a tomb would be located in the sacristy.

Against this framework, let us refer to a document of a vicar, César Brudinou, dating from the 17th century. This vicar asked for, and had fulfilled, works in the church. He employed a shaft sinker and two masons (which he got from Rome, Italy). The three men worked for twenty one days, without any break, to clean and restore the fabric "sealed in the undergrounds of the sanctuary". When the job was completed, they left. Brudinou apparently stated laconically that these were "voluntary workmen in a quest for penitence". It seems that somehow their twenty one-day shift was part of this penitence. It has to be said, though, that they did take one break: when mass was said, which they apparently attended.

Were there no local workmen knowledgeable enough to do the job? And were the closest available experts really only available in Rome? A more likely scenario seems to be that a foreign workforce, only speaking

The church of Notre-Dame-de-Marceille from the bottom of the hill, near the route to the vault

Italian, would have been a much better option when "discreet" work needed to be done. Furthermore, as they were from Rome, it is not beyond the bounds of probability that they were also used by the Vatican – and that they were therefore approved and classified as being able to hold secrets – to be discreet. Perhaps they had signed some sort of an official secrets act... Even if they were not "Vatican agents", or might not be able to hold the secret, then it is clear that as they had no holidays, there was no chance that they would go and spill information to the locals. If they were indeed penitent, it is clear furthermore that there was no room for alcohol – the Blanquette de Limoux would not have been able to loosen their tongues.

The underground complex of the church was obviously in need of repair, but it seems that the person requesting the work to be carried out knew very well that no-one was allowed to know what was underneath. Hence, he had to go as far as Rome to find a workforce.

It is clear, too, that this work was to be forgotten – not even to be known about. We did chance upon this document, but only in a very circumspect way: it was found in the archives of the Penitent order of St. Bertrand de Comminges. It was located in a batch of files and religious memoires belonging to the castle of Barbazan, near Montsaunès. But at the same time, it is obviously a very important document. To some extent, it proves that there is something underground at Notre-Dame-de-Marceille. But above all, it proves that in the 17th century, that something was in need of restoration. Furthermore, it is clear that somehow, these workmen had access to it from somewhere on the surface.

So much for the church. Now let us consider the well. A well obviously penetrates into the ground – and might thus lead to the underground complex. It would definitely be a straightforward access route, easy to miss ... and could explain how the thief was able to enter the church and steal the Black Madonna at the time of the French Revolution. Furthermore, the well might have been an element in a regulating or draining system.

The well inside the church had no practical purpose. The "miraculous spring" was located outside. Then, towards the 20th century, the decision was made to close it off completely: it was covered by paving slabs and today, any visitor to the church sees no visual sign that would betray the presence of a well inside the building. So, it would be logical to close it off. There was no apparent reason that it should be there, and a decision might have been made to remove it completely from the church's premises. It was a potential danger, in more ways than one. At the same time, it was a lot of work for little benefit. If it was just a health and safety hazard, a nice metal grid could prevent any accident. After all, in normal circumstances, such wells are looked upon nostalgically, like the

presence of the stone that fell from the ceiling, which is still kept in the church.

The well might have been the route for the burglary. The identity of the thief is unknown; the identity of the person who "recovered" the statue is known: François Lasserre. As mentioned previously, he was a prior of the Blue Penitents. And it is in that order that the note of Brudinou was unearthed. Is this a coincidence? Or were these the people that knew and operated the underground complex, perhaps like the Roman Salians before them? Also, note that the three Roman workmen were also on the premises as part of a "voluntary penitence". Three times seems to be a bit of coincidence. Penitence and knowledge or exposure to the underground complex seem to go hand in hand. But that is not all: another person who seems obsessed with penitence is Bérenger Saunière of Rennes-le-Château: he would engrave on a Visigothic pillar the words "Penitence, Penitence". Is this another coincidence? Or is there a possibility that there was a connection?

Who were these Blue Pentitents? They were congregations whose statutes emphasised penitential works, specifically fasting or other forms of discipline. God, they seemed to believe, could only be experienced by pain – suffering: deny the body pleasure, so the spirit can experience light. The number of such confraternities increased to such a degree that they soon were classified according to the colour of their robes, most often worn for processions or devotional exercises. This brings to mind the group of people known to move about at night around Notre-Dame-de-Marceille at the time of the Revolution. Although they were believed to dress in black, could it be another dark colour, like blue? Was a group of Blue Penitents active in this area? The answer seems to be yes, specifically as Lasserre was the one who "discovered" the statue, and documents on Notre-Dame-de-Marceille were recovered from their archives.

It is known that these confraternities often had their own churches and even their own cemeteries. Maybe some chose Notre-Dame-de-Marceille as their habitat.

First, let us assume this group of people did wear black and were penitents – this would have made them Black Penitents. The chief confraternity in this group was that of Misericordia, or of the Beheading of St. John, founded in 1488 to assist and console criminals condemned to death, accompany them to the gallows, and provide them with religious services and Christian burial. Intriguingly, other confraternities of Black Penitents are those of the Crucifix of St. Marcellus, a 4th century pope (feast day January 16).

The Blue Penitents, however, had confraternities in many regions, specifically in Rome – where, in total, more than one hundred

confraternities lived. In France, a number of these confraternities were established under the patronage of St. Jerome. In all these organisations, aspirants had to serve a certain time of probation before being admitted. But let us return to our resident hermit, Antoine Daude, whose presence on site coincided with the repairs carried out by our Italian workmen. It was also the time when Mgr. de Rébé carried out his round of inspection and asked for the burial of the uncovered stone statues. But that is not all. He asked that daily, shortly before nightfall, the church should be closed. He asked this both of the overseers in the church and of the hermit. Why? It seems that the bishop wanted to perform activities on site that might cause people inside the church to become suspicious – perhaps the odd sound, or perhaps a particular interest in a particular corner of the church. Again, it is evidence that de Rébé was on the prowl for something, and that he was not alone.

Let us go back to the remark made by R.P. Migault, when he writes that Daude accepted the "habit of hermit from the hands of Mgr. de Vervins". It is a strange way in which to become a hermit. It suggests that Daude was either employed or initiated – rather than following a vocation. Furthermore, the "dress of a hermit" is not specific, but the dress code of a secret society, a fraternity – such as that of the penitents - often is. Furthermore, the name Daude is quite intriguing, for the river Aude runs at the foot of the hill. Was it, therefore, Daude or d'Aude? Was our hermit simply called "Antoine", who lived along the Aude?

However, more strangeness lurks along the river. Hermits were notorious for living far removed from civilisation. Although Notre-Dame-de-Marceille might seem far away when compared with Limoux's market square, it is in fact, often busier! The basilica was a place of pilgrimage and the many visitors would make the sought-after solitary lifestyle of a hermit impossible.

Therefore, a more likely scenario is that the hermit was a "guardian", someone with a specific task, to be on site and make sure that anyone, who might drift off the path, could be stopped in his tracks. Furthermore, a little publicity near the church could state that somewhere nearby, lived a hermit, which would obviously have meant that the pious pilgrim would not venture near – a hermit, after all, wanted solitude. A pilgrim, in search of penitence himself, would make sure that he would not upset his fellow seekers for the blessing of God.

Nevertheless, although a hermit there was, a hermit was not mentioned in the archives. Despite the fact that we do know that he lived there from 1610 till 1656, when he was buried in the church, on 17th September, where exactly was he buried? In the church itself, or nearby? If so, why the exception, when we know that apparently no-one else was buried there? Was it a favour, as, after all, he did live there – where else would

they bury him? We will never know why. Still, in the introduction to his book, R.P. Migault mentions that "caves" were filled in about 1860, in the chapel of the Cross. Therefore it seems that towards the 20th century, a different policy was pursued, in which the caves were filled in, the well was closed – and the former existence of the underground chambers was forgotten.

The question to ask is why was the underground complex filled in? Was it no longer deemed important? Was it too difficult to keep secret or operational? If it ever contained anything important, had that "thing" now been removed elsewhere? Again, these are questions with no obvious answers. But there is clearly an obvious pattern.

Today, any visitor to the church will find it difficult to imagine that there was once a deep water well in the nave. Furthermore, most guides no longer refer to its existence. The most recent document that still refers to it is by Migault, written in May 1962. The modern guide merely lists an ancient drawing of the building of the church, in which the well is still depicted.

Still, we have some further details about this well. It was situated on the opposite side of the entrance. According to a technical study by Professor Pierre Verdeil, of the Faculty of Sciences of Montpellier University, the internal diameter of the well was 1.6 metres, the depth close to 8.5 metres, with the height of the water level apparently constant, at approximately 0.8 metres.

The well was apparently dug in a "molasse", made up from gravel, sand and pebbles. At a depth of 7.65 metres, the lining was made from stones from the river, assembled without mortar; the bottom of the structure was left untouched, to allow the free flow of water. A blockage of approximately 1 metre, using the stones from the river, ensured the integrity of the native ground. Furthermore, it was stated that the bottom of the well took the form of an upturned cone, thus allowing the water to be used until the reservoir was completely drained.

All well and good, but it does not explain why the well was there. Furthermore, this report suggests that the well could not have been used as the method of access for the thief, who stole the Madonna, suggesting that there is another secret connection between the church and the underground complex – or that the guard was indeed an accomplice in the theft of the Madonna.

The well therefore defies all logic, for not only did it apparently not conceal a secret access, there was no reason to build the well there. Slightly further south, it was easily possible to obtain large quantities of subsoil water. Why anyone would want to make a well here – from a purely logistical perspective – defies all logic.

Nevertheless, some scenario could be constructed. Perhaps water was required in that specific location at some point, either for agricultural purposes, or for animals – or humans – living in that specific location. Or perhaps the well was dug to create a system in which the height of water could be regulated elsewhere, for example to submerge underground galleries. So perhaps we should state that there are "logical reasons" why there would be a well there; it is just that these reasons do not fit easily within the official framework of the story of Notre-Dame-de-Marceille.

P. Verdeil himself included the statement that the site was the location of a Roman camp – a statement we have come across earlier. But it seems Verdeil stated that although the site had ideal defensive qualities, he felt it could not have been the location of a Roman villa, as the quantity of water on site was too small for the needs of a farm. The small but regular quantity of water could nevertheless have been sufficient for a small garrison, or ritual ablutions – if we were to accept the theory that there was an oratory to the god Mars here.

Verdeil also stated that the conical form at the bottom of the well was proof of an Arab presence on the site. Such hydraulic systems are frequently found in North Africa and it is known that the Spanish Moors occupied the territory. Furthermore, it seems that after the Arabs re-engineered the structure, it was left intact, until a curbstone was added later.

Most interestingly: Verdeil also spoke about an experiment, which we know was carried out at the beginning of the 20th century. In this experiment, an inoffensive dye, often used to trace underground rivers, was added to the water. The purpose of the experiment was to see where this specifically coloured water ended up – normally along a river. But in this instance, no single trace of the coloured water was found. Wherever the water went, the experiment could not reveal that location - or rather, not totally. The coloured water was found much further downstream, in a place where one person, Paulan Curto in 1826, had postulated the presence of another well. This well was connected with an unverifiable legend, but perhaps there is indeed no smoke without fire.

On top of the well, an inscription reads: "Omnis qui bidit banc aquam si fidem addit, salvus erit." In essence, it states that all those, who drink, will be saved. We do not know how old the inscription is, nor who left it there.

Verdeil stated that the quantity of water was hardly significant: at most, 2200 litres each day, 68 litres per day at worst - in short: inconsistent. It is an astonishing observation, when we know that at the end of the 19th century, water was so abundant that it literally "sprang", by means of a pump, in the chaplain's building. This is the observation of one Theo

Lasserre, and one Henri Boudet – the latter being a priest of Rennes-les-Bains and friend of Saunière. Furthermore, it was this duo who stated that there was a second inscription, this time engraved on the curbstone: "Hic puteus, fons signatus; parit unda salutem. Aeger, junge fidem: sic bibe, sanus eris." According to Lasserre, this translated as "This well points to the sealed fountain. Its limpid water has the virtue to cure. Patients, have faith: drink this water and you will be restored to health." The priest is then quick to point out that the legend is without any foundation. In his opinion, in spite of his extensive research, apparently no-one had ever benefited in any miraculous fashion from this water.

Lasserre then specifies that this well was originally dug outside and opposite the Roman chapel. With the enlargement of the modern church, it was incorporated in the enclosure and reverently preserved.

These new details make the presence of this well completely illogical. Or not so much the well itself, but what was done to it. The visitor was invited to "drink from the well", as it would cure any ailments. The visitors would certainly do so, but nothing ever happened. It is clear that the statement of the curbstone was a lie – a fabrication. Why? There was enough genuine mystery and devotion present in the church. Its operators did not require the creation of a new "mystery", which would in fact be very dangerous, as the visitors might have caught on to the fact that no "miracle" ever came about from drinking the waters of this well. The best things canons could have done was never to have put the inscription there in the first place; but once there, the second best option would have been to have removed it as soon as possible.

So many questions now arise. What about, for that matter, the primitive Roman chapel? And another question, quite distinct from those above: how was Lasserre able to mention so many details that are not part of the official church history? It seems that he must have had access to documents or information that were inaccessible to other researchers. Furthermore, it seems that his friend and colleague, Henri Boudet, priest of Rennes-les-Bains, friend of Berenger Saunière, was also familiar with this knowledge.

So where does this leave our "sealed fountain"? Where is it? Why is it sealed? Why is it important to mention it? Is its status connected with the reason why visitors should drink it? Once again, so many questions, but no ready answers.

Scellé, "sealed" in French, has several meanings. In the so-called "Green Language", where pun is often used to mask other, esoteric meanings, its primary meaning is that of "closed hermetically" - sealed - locked away from the outside world, either because it had to be kept a secret, or because the sealed object itself might have been dangerous if it were not hermetically sealed.

83

The secondary meaning of "sealed" is marked – identified – stamped - signed, sealed and delivered. In its third meaning, the pun is towards the word "scelle" or "scel", a word originating from old medieval French, often used in alchemy, and illustrating the Philosophic Salt, the symbol of matter. This meaning, of course, ties in with the two former meanings, but whereas they were understood by the general public, though perhaps not in its symbolic manner, the third was not.

In its third meaning, Notre-Dame-de-Marceille is suddenly transformed into a place where initiates practised alchemy... and it is there that a fountain, such as the fountain of Youth or the fountain of Knowledge, is at the centre of the alchemist's quest. It is from Alchemy, or the science of the Greek god Hermes (the Greek counterpart of the Egyptian Thoth), that the phrase "hermetically sealed" is derived.

There is even a fourth possible interpretation: this one is connected with heraldry, where a blazon, or coat of arms, is said to have been "sealed" when it is guaranteed to remain in its present state, so that it can no longer be modified. The blazon is therefore "eternal" – sealed.

Thus, whatever meaning we should go for, the fountain is clearly associated with the spring. The engraving on the curbstone is precise, unambiguous. It imperatively invites anyone who leans on it, to "have confidence, drink this water and you will be restored to health!" Was this a message left for the initiates? Those pilgrims seeking not penitence perhaps, but initiation – enlightenment: light coming out of the darkness? Whatever the case may be, today, the fountain itself is hermetically sealed, obscured and forgotten.

Was the water from the well used in the underground complex? Was it used by initiates – penitents – in search of something, guardians of whatever? Was it the water used in a ritual, a baptism by water, the symbol of initiation? Whatever it was, Lasserre concluded that it was not miraculous. But if it was "secret", why were all visitors invited to drink it? It is just one more contradictory observation that can be made about the well inside the church.

Although we are sure that the well must have had a purpose at some time, it is clear that in the past two centuries, a decision was made to remove it from memory. It is also clear that the well is somehow connected with the underground complex, but how precisely, is unknown. Furthermore, it is obvious that the well and the complex were originally secret, and filled in later – more recently, before all references to them were carefully thrown away in the hope that the mists of time would obscure knowledge of their existence – including their present existence. For it is clear that the complex does still exist; it just seems to be no longer accessible.

Chapter 11
The Sacred Path

Another expert on Notre-Dame-de-Marceille was, as already hinted at above, Henri Boudet, the priest of Rennes-les-Bains, colleague and friend of Berenger Saunière. Boudet wrote some of his knowledge down in his book, La Vraie Langue Celtique et le Cromleck de Rennes-les-Bains, published in 1886. In chapter VII, on page 277 of the original edition, he writes: "A little distance away, at the top of the slope next to a line of green trees leading to the sanctuary, a fountain drops limpid water into a marble basin. After heavy rains, the water continues to drop with uniformity, and during times of great dryness do not stop. The innumerable Christians who will pay homage to the Holy Virgin, stop for a moment at the fountain, and after having said a prayer, draw some drops of this water with which they wet their poor feet."

On page 279: "The fountain of Marceille has been, like others, decorated with a statue of the Blessed Virgin. This was the statue that was lost amidst the storms of Saracen invasions, was later found and placed with honour in the sanctuary that was built to receive it. That appears to us as extremely likely. This image of the Blessed Virgin, holding her divine Son on her arms, and carved in a black wood indicates her Eastern origins. Its position is near a fountain, and it is in a field close to the small spring that it was found, in the earliest times of Christianity's presence in Gaul. These probabilities take on an even more serious form, if we seek to penetrate the meaning of the name of Notre-Dame-de-Marceille or Marsilla."

There are more references in his book, but we will refrain from repeating them here. The only question we do want to pose is what did Boudet mean when he wrote that the origins of the statue and the spring would take an even more serious form if anyone was trying to penetrate the meaning of the name Marceille or Marsilla. It is an intriguing reference, as Boudet does not enter into further detail on the subject. Nevertheless, the text does invite the reader to study discreetly this aspect that seems to be very significant to him when someone tries to understand the mysterious origins of the place.

As mentioned before, the modern traveller's approach to Notre-Dame-de-Marceille is different from the traditional one. The "sacred path" was never and would never be suitable for cars. At the same time, it was clear that even if there were an off-chance of such a thing happening, it would ruin the charm of the ancient access route to the site. The "Fontaine de Notre-Dame-de-Marceille", which, according to Boudet, was the official name of the miraculous spring along its side, would be reduced to a

roadside attraction. Boudet was probably correct in this description of the fountain, as there is a mention of it in an almanac of 1721, under the name of "La Font de Marsilla".

This spring might have been part of the original megalithic complex located here; it is known that our megalithic ancestors often incorporated sacred springs into their ritual complexes. This should not cause major surprise, as specific natural sites were normally singled out for worship. Notre-Dame-de-Marceille ticks most boxes of what could be described as a "megalithic sacred site template pick list".

The question is whether the complex was as would be expected in megalithic sites, or whether it was more vast – expanded on later, perhaps by the Romans. This could explain the presence of an underground complex. Note that the statue of the Black Madonna was discovered in the field just below the miraculous spring.

A water divinity would guarantee the flow of the sacred waters. It is possible that this water had mineral virtues with curative properties for certain eye-diseases. Thus could be born a place for worship centred around the magical and beneficial effects for those who came to beg for the favours of a goddess of water. In all pagan contexts, springs and eyes were linked: in Hebrew, the word "ayin", has both meanings; it is a clear example of how pun was used long before the French language used it in the past several centuries.

We know that Boudet used such pun in his "explanation" of how the Celtic language, which at that time was largely believed to be the language spoken by the megalithic builders, was identical to modern English. According to Boudet, "Marsilla" could be explained as "the eyes spoiled", damaged or closed by the disease: "to mar", which could only lead to "Marseel", or "Marsil", from which came Marceille. It might seem farfetched, but at the same time, it does not stray too far from the other legend connected to the site, that of the wounded Roman soldier who, though dead, somehow had retained an uncommon clarity in his eyes. In death, his eyes remained alive. Already, this legend could reflect religious contamination if the spring was already connected with an "eye goddess" during Roman times. In fact, it is more likely to be so in this manner than it would be the other way around - that the story of the Roman soldier would create folklore about the healing properties of the well.

There is another possibility related to this. If the spring was already deemed to be miraculous and possess healing powers, it might explain why the Roman soldiers carried the dying Marcellus to it. Using the same imagery of the Holy Grail, perhaps the water of the spring was thought to heal the injured soldier. Perhaps the imagery of the "clear eyes" was retained to suggest that even though he died before reaching the site, water might have been sprinkled on his body, which resulted in his eyes not succumbing

The sacred spring, along the sacred path, said to cure illnesses of the eyes

to their usual dead state, but instead retained their clarity.
Therefore the final question should be whether or not the water is indeed miraculous; could it heal? The answer is that no-one knows. No mineral analysis of the water has been performed. The only observations we know of is that the flow of the water is low, but regular. During periods of great drought, or heavy rains, the quantity of water remains stable.
In the old days, pilgrims would climb the "Voie Sacrée", the Sacred

87

Path; 52 stone steps, which ascend from the bridge across the river to the top of the hill. The stones are boulders from the Aude, running at the bottom of the hill. The path was an imitation of the Via Dolorosa, the path walked by Jesus Christ carrying his cross before his crucifixion. The pilgrims did not carry a cross, but did climb the hill on their bare knees. With such symbolism incorporated into the design of the path, we need to ask whether it is a coincidence that the number of steps is identical to the number of weeks in a year. Did each step equal "penitence" for the sins of one week? Although it is impossible to answer this conclusively, an early indication might be to suggest it is not a coincidence.

Although we ourselves have not performed the task of climbing the sacred path on our bare knees, it should be clear that it would be painful, though not impossible. Any person with no serious knee problems would be able to do it. The challenge is not so much in the task, it is in the contact of the bare knees with the cobbles. The climb itself is gentle, and never steep or dangerous.

While performing their ordeal, having almost reached the top, the pilgrims saw the spring and were invited to use its waters. The Virgin could heal a thousand evils through this flowing water, but above all, it seems, ocular problems. Some would drink, some would bathe their eyes in it, or wash themselves with it. Still others would carry it in their cupped hands and would enter the church, "sanctifying" the water before drinking or washing. As is customary in Lourdes, perhaps small containers were filled with water, for future use, often at home – or for a person too ill or old to travel, who would be given the sacred water by the pilgrim who was making the voyage on his or her behalf.

As it had a reputation for curing eye diseases, perhaps the scenes during a pilgrimage were that of groups of people helping a blind person along the path, guiding him, from darkness to – hopefully – illumination, all along the pilgrimage route, and up the "voie sacrée".

But if the water was famous for its healing properties, once again there are no accounts of miracles. So far we have two springs, both deemed to be miraculous, yet both without any proof of miracles having taken place. It is a tradition unsupported by documentation. As a result, Notre-Dame-de-Marceille does not sit within the framework of sites such as Lourdes, where it is said that the Virgin has performed quite a number of miracles. Each time such a claim was made, more and more visitors would flock to the site, but at the same time church officials would investigate the claims. That never seems to have happened at Notre-Dame-de-Marceille. This begs the question as to whether the source was not miraculous at all, or whether the local officials decided never to seek official recognition of the miracles. Once again no definitive answer can be given, but it is clear that an increase in visitors and the gaze of the

public eye might have spelled trouble for those who had to guard over the secret underground complex. At the same time, it is possible that the miraculous spring was only deemed "miraculous" because it had existed since Celtic times – pagan times. In these cases there was normally a clear hands-off policy from the Church – for which we do have evidence, from Ancé.

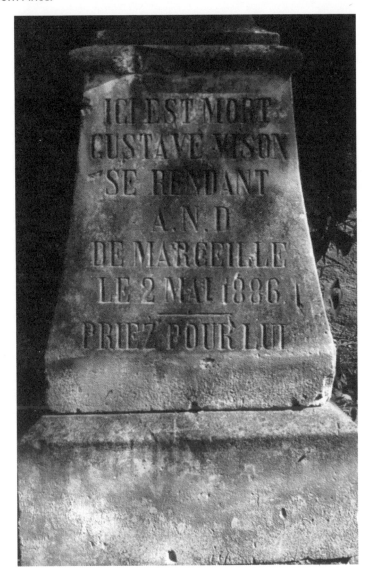

The Vison stone, commemorating the death of one "Gustave Vison"

89

Still, one religious congregation holds a small phial of this liquid; it has been hermetically sealed for almost three centuries. The seals attest that the bottle has not been opened since 1737. A cursory investigation of the sample shows that the water has retained its transparency; there is no trace of it having become brackish. The water has remained as crystalline as it was in 1737, when it was collected from the spring.

Nevertheless, there are stories that the water has become opaque, specifically during times of war, famines or testing times for the site of Notre-Dame-de-Marceille. Although these accounts have been written down, they should perhaps be taken with a pinch of salt – no pun intended. For if the accounts were true, then it would mean that this water is indeed miraculous, and even "mourns" the circumstances. But the question should also be asked whether it was just the sample, or also the water from the spring, that turned opaque at such times. Again, there is no available answer to that question.

With no answers to this mystery, let us mix in more mystery. Somewhat below the sacred spring, on the same side of the path, is a stone stele. The monument which, in the past decade has been subjected to vandalism from youths, who felt it was a perfect canvas over which to spray yellow fluorescent paint, appears to be just like any other monument. It has the same shape and the same inscriptions present in all other memorial stones. According to the inscription, it marks the exact location where a person died, probably during his pilgrimage to the sanctuary on top. The inscription reads:

ICI EST MORT
GUSTAVE VISON
SE RENDANT
A.N.D
DE MARCEILLE
LE 2 MAI 1886

PRIEZ POUR LUI

HERE DIED
GUSTAVE VISON
RETURNING TO
N.D
DE MARCEILLE
MAY 2, 1886

PRAY FOR HIM

The information gleaned from this stone is straightforward. Gustave Vison, possibly on pilgrimage, did not make it all the way. Within sight of his destination, he fell dead, on May 2, 1886. His family or friends then decided to build this memorial stone, obviously with the intent that people would remember him. Although he himself could never ask the Virgin for forgiveness, for penitence, his family asked that others would now pray for his soul – and remember him – whilst they made their way up the path.

What could possibly be weird about this? At first nothing, but doubting everything, and it being Notre-Dame-de-Marceille, it should be clear that nothing is straightforward. Vison died in 1886 and as a matter of interest, we felt it should be possible to find administrative documents surrounding his life and death. This would be the norm, rather than the exception. Furthermore, such a death would leave more traces – newspapers, other documents, etc. From a purely medical perspective, the body must have been removed from the scene, most likely taken to the hospital of Limoux. In centuries before, no doubt the poor man might have been swept away and quickly buried, but in 1886, "procedures" had to be followed. A death certificate would have to be produced. Furthermore, as the death had occurred on a public highway, there was a mandatory investigation by the Gendarmerie, the French state police, resulting in an official report. In the case of Gustave Vison, this investigation would most likely have been short and to the point, nothing more than a bit of paperwork. But the case would be

investigated, and closed. Files archived – for posterity. Once completed, if the victim did not live within the jurisdiction of the magistrate, the family would claim the body and it could then be buried in a location of their own choosing. If the body was not claimed, it would be buried in the local cemetery.

For Mr. Vison, it would therefore be easy to obtain the following administrative documents:
· the death certificate
· the admission papers to the hospital
· the report into the cause of death
· the conclusions of the investigation and the official approval of those conclusions.

With these four documents in place, there would then be evidence to find out where Gustave Vison was buried – the memorial stone marking the location of his death, not the location where he was buried. Simple, straightforward and achievable tasks for anyone in most areas of France, in the late 1990s.

The first investigation was carried out by Jos Bertaulet. Though his age prevented him from doing a detailed enquiry, he did find that the name Vison, though at first looking extremely French, was apparently a non-existent French surname. He pointed out this oddity and after his death, André Douzet would try to find the above legal documents. For several years, in spite of several searches through the administrative documents, nothing was found regarding a Mr. Gustave Vison, or his death at Notre-Dame-de-Marceille on May 2, 1886. Sceptics might doubt our investigation, labelling it erroneous or too small in scope, but we would invite them to come up with the death certificate for this man – or any other document regarding him.

There was apparently no death certificate. No admission papers bearing his name for this period at the hospital of Limoux. No traces of an official investigation into the circumstances of his death. Nor even are there traces with the regional Catholic or Protestant archives. And, indeed, the name Vison is completely unknown in the area.

Even if Vison was a marginal figure, perhaps a gipsy, perhaps a foreign pilgrim, perhaps an orphan, perhaps someone without any family... irrespective of all that, there would be official paperwork. And the memorial stone suggests he had family, for surely no-one would erect a monument to a complete stranger?

But Vison must have been rich, as the memorial stone would have been expensive. Its erection would have required the approval of the owners/operators of the sanctuary at the time – more paperwork, which does

not seem to exist. Furthermore, as he no doubt had a family, why there is no trace of their existence – or his existence?

Some options remain. First, for some reason, impossible to determine, someone might have made all paperwork disappear. Not only concerning the death of Vison, but also that of his entire life – and family. Why the memorial stone was left untouched, would be a major mystery. A "young person dressed in black" could surely have smashed the stone to pieces at night, leaving the priests with no alternative but to remove the memorial stone altogether – or to contact the family to inform them of the sad event and ask whether they would be willing to pay for a new stone. The second scenario suggests that Mr. Vison had never lived – and thus could never have died. We can only feel sorry for those pious pilgrims who have been praying for him over the past century.

For a long time, the second scenario seems to be the most logical. But: if he never existed, why erect a memorial stone? Who was behind this prank? And what was its purpose? The first to suspect that perhaps the stone was a riddle was Jos Bertaulet. He focused specific attention on line four of the inscription, which is made up of abbreviations. "A.N.D" Logically, this could be "A Notre Dame (de Marceille)". But if they were proper abbreviations, you would expect A N.D., with a full stop behind the letter D as well. Instead, only the first two letters are followed by full stops, the one after the A being somewhat erroneous, as it is a proper word in its own right: "à" – "at". An error? Did our inscriber misplace the two points? Possibly, but it should be made clear that when we combine all the errors in inscriptions both at Rennes-le-Château and at Notre-Dame-de-Marceille, it seems that the areas did not have a single competent stonemason between them! No wonder that, for restoration work to the underground vaults of Notre-Dame-de-Marceille, perhaps it was decided to bring in stonemasons from Rome! And what about Rennes-les-Bains, where undertakers and stonemasons even made two tombs for de Fleury! Such joking aside, it is clear that these errors are not accidental – at least not in all cases. After all, we know that when asked to perform good work, the stonemasons were able to build to specification, as is in evidence in Rennes-le-Château with the church and the Villa Bethania, which one century later, still stand firm.

So instead of A N.D., we have A.N.D, very close to the English word "and". We only mention it because we note that in 1886, there was one man with an interest in both Notre-Dame-de-Marceille and English, and that man was Henri Boudet, who in that year, had his book on the true Celtic tongue, published. Furthermore, he was a man who seems to have had an interest in pun; a man who was familiar with superfluous tombs in his cemetery at Rennes-les-Bains – and perhaps decided to export that custom to Notre-Dame-de-Marceille? At this moment, such allegations

might seem unfounded, but they need to be taken into account here – it was Jos Bertaulet who suspected that the stone was the handiwork of Boudet. Bertaulet identified him as the main suspect because he felt that the strange affairs of Boudet and Saunière centred on Notre-Dame-de-Marceille. We will introduce the evidence piecemeal over the following chapters, but focusing on the memorial stone, Bertaulet felt that the stone was a "key", left behind by Boudet, understandable to those who had "eyes to see" – the joke of course being that the stone was in the immediate vicinity of a sacred well said to cure bad eyesight. Bertaulet thus felt that Boudet had placed the memorial stone in a specific location from which the observant person – who knew where to look and had good eyesight – could see what he was looking for: the object of the quest which Boudet had been pursuing. And the follow-up question is whether, therefore, this was also the quest which involved Saunière, and whether this was related to the source of his wealth – and his many mysterious associations with people as far away as Lyons.

But this scenario changed in 2003, when a new, wider search did uncover the existence of Gustave Vison. What had transpired, was that Vison had died on May 1 – not May 2, as was indicated on the memorial stone. It shows how simple errors can have big consequences. But that was not all. In spite of this information, all documents surrounding his death were still not to be found locally. The only information the archives of Limoux could furnish was his date of birth, and that he was from the

The death certificate of Gustave Vison

Alsace region. With this information available, a dramatic new interpretation came about. The official version was that Vison had existed, and had died of a heart attack. He was said to have succumbed to a heart attack, had taken to Limoux for medical attention, but had died. The following day – May 2 – his death had been reported to the authorities, and his body made available for an autopsy.

But that did not correspond with the autopsy. The autopsy revealed that the cause of death was not a heart attack, but several fractures, suggesting Vison had fallen. Obviously, though it is possible to fall on the cobblestones leading towards the Basilica, not even the frail of bones could fall in such a matter that the ensuing fractures would cause death so soon afterwards.

The likely scenario, therefore, was that Vison had been involved with something that had to be kept secret. Suppose Vison had fallen in the underground complex, and had died there – or was at least on the brink of death. There was no possibility that his colleagues would make the site known to the authorities, to reclaim his body. Instead, they removed it from the complex, and took it with them to Limoux. The following day – or a few hours later – the authorities were informed of his death, and the circumstances of his death slightly altered.

Some might suggest this scenario is too far-fetched. Under normal circumstances, it would be. But Vison was no ordinary man. As mentioned, he was not local, and neither was he a pilgrim – at least not an ordinary one. Vison was a member of a secret society.

We found evidence of the death of Gustave Vison in the archives of the Civil authorities of Limoux, where it stated that Vison had indeed died on 2nd May 1886, in a house in that city.

What is immediately striking is that the officially recorded circumstances of his death bear no resemblance to the inscription on the memorial stone. The official notes say that his death took place in a house in Limoux, the stele says he died on the Sacred Path in Notre-Dame-de-Marceille.

The registered document states: in the year 1886, the second day of the month of May, at eleven o'clock in the morning, appeared in front of us, Eugène Vanduran, officer of the Mayor of the Civilian authorities of the city of Limoux, of the canton of the same name of the Department of the Aude, Mr. Pierre Cavenas, aged 69, turner, and Antoine Cavenat, aged 58, shoe-maker. Living in the city, neighbours of the deceased, who declared that on that day, at 8 o'clock in the morning, Mr. Gustave Vison, aged 65, retired salesman born in Metz (Moselle), living in Limoux, husband of Mrs. Isaure Ducros de Saint Germain, living in Narbonne (Aude), son of the deceased Pierre Vison, retired officer, and Mrs. Marie Stocky, without occupation, died at Oran (Algeria), had died in the house of the widow Mrs. Pierre Chanaud, rue de l'hospice, number 1,

95

and we signed the present act after it was read to those present, and after being assured of the death, we delivered the authorisation to bury him."

With this information, it is clear that any search for a Gustave Vison dying in Notre-Dame-de-Marceille would be unsuccessful, and it begs the question as to why there is such a major discrepancy between the memorial stone and the official document. Also, it is clear that neither Vison nor his family would be likely to tell a lie and erect a disingenuous memorial stone. Still, it is clear that he was a man of means, as his wife belonged to a prominent family from Narbonne. Also, if his family were responsible for the memorial stone, it remains a puzzle as to why there is no trace of it in any archives.

There are also other differences between this act and expectations. As officially, Vison died in a house, it would require less paperwork – and less investigation, such as an official enquiry. Nevertheless, that was not all that we discovered about his death. The civil authorities in France maintain what can best be described as an "observation log". This is a record of events that the authorities note down, but do not or cannot investigate. A good example would be of a UFO sighting, in which a member of the public reports the sighting, but the authorities can only note it down, without taking further action.

There is a similar entry for the death of Vison. It notes that Vison's body had suffered several fractures, suggesting he had fallen. They were considered to be serious injuries and were felt to have contributed to his death – if not caused it. This would suggest Vison had fallen. If true, one would suspect he had fallen down stairs. But it does not explain the memorial stone in Notre-Dame-de-Marceille.

With this new information, we were able to trace certain details about Gustave Vison. We learned he was a member of a society that had Martinist and Synarchic tendencies. His presence is noted in several newsletters. He was introduced to these organisations by an important member of his wife's family. We also noted that as a salesman, he often went to Rennes-le-Château and Rennes-les-Bains, for "trade" and "other matters". Another possible scenario might therefore be envisioned. Perhaps Vison was indeed present in Notre-Dame-de-Marceille, possibly on the night of 1st May 1886. Possibly, he was working in or visiting the underground complex there; he might have fallen. People with him, or people who later found him, might have taken him to Limoux. He might have already died on the site, or might have been close to death. However, keeping the secret of the site was the most important thing, and he could not be discovered there. Nevertheless, afterwards, a memorial stone was erected in Notre-Dame-de-Marceille, commemorating his death, as a reminder to those "who knew", of what precisely had happened to him.

Chapter 12
Trips down memory lane

So, the big question: is there anything underneath Notre-Dame-de-Marceille? Apart from earlier indirect evidence, there is one document which specifically mentions "cavities under the river". The document comes from the beginning of the 17th century, a time when great epidemics struck the area, Carcassonne in particular. At the time, so this document informs us, access to these cavities was "easy".

This information came about because at the time, a simple mechanism to dispose of huge amounts of infected, dead bodies was required. These pits had to be distant from the town, so that they could be used as "epidemic pits" – i.e. to bury people so that their dead bodies would pose no health risk to the others. They would be burnt or covered with quicklime. The authorities investigated various possibilities and came back with the statement that there were already some huge, very old "containers" near Limoux – although people had forgotten they existed. Preparations were made to enable access to this site. But because of the proximity of the river Aude, the project was quickly abandoned. Indeed, handling and disposing of infected corpses next to a river that fed the entire region was not a very clever idea. However, in the mean time, between initially approving and finally stopping the project, some work had already been done, specifically in enabling access to the site, on the right hand side of the river Aude, at the foot of Notre-Dame-de-Marceille. These caverns were said to be large, although there were more modest underground vaults, in the form of some sort of underground cistern of a lesser quality, on the left bank, further downstream.

The entire project fell within the remit of the civil authorities. Area manager was Louis Charles de Pennaud, from Toulouse. This expert was scrupulous and meticulous, keeping long accounts of his investigations, which he sent in the form of administrative documents to the proper authorities. Civilian authorities – not religious authorities.

Thus, we find some of these reports in the files of Mr. September, the former principal of the Ecole Normale, who used these reports as evidence of the presence of Visigothic remains. The documents list the technical admiration Pennaud had vis-à-vis these "underground bases", which were situated on and sometimes below the water level of the Aude, even though water did not seem to infiltrate the structures. However, he did state that if the river were to rise quickly above its normal level, the entire system would be sealed.

These notes were carefully preserved in the archives, held by the heads of the engineering department of the Department of the Aude; they

could be consulted at any point in the future, should they prove to be useful. One such use might be the installation of a regulation system to control the level of the river. But although the documents existed, the site itself would never be revisited.

A copy of this report would actually be deposited in the archives of Notre-Dame-de-Marceille, because of a lack of space elsewhere. There, the files were either never consulted or were gradually destroyed. The last administrative trace goes back to 1897, when it is discovered that the file itself no longer exists, although proof that a file once existed, is still found. It seems that the destruction occurred in 1892, when all files were transferred. They were either destroyed, dispersed or lost. Only a small, almost negligible part remains, recovered by collectors of old documents such as Jean-Christin Maillot and Charles Bunyeux. This information is still in the possession of the heirs of J.C. Maillot, where we were able to examine them.

Maillot himself did not merely collect these documents; he continued the observations first made by Pennaud during the 17th century. It will never be known whether Maillot observed purely out of interest, or he had a more specific purpose in mind, but he definitely went so far as to carry out work in the locations mentioned, i.e. at the foot of the hill of Notre-Dame-de-Marceille. Subsequently, he tried to produce a small publication on his observations, but when his idea did not get a favourable reception, it seems he gave up on the entire project.

Nevertheless, his notes, which formed the basis for his publication, clearly affirm that he found the network of underground constructions, close to the river Aude, at the foot of the sanctuary. Maillot entrusted a copy of his notes to a scholar from Narbonne, who provided some feedback, specifically on the possible dating of the complex.

It appears that the entire network was not only of excellent workmanship, but still in a satisfactory condition. Nevertheless, Maillot was unable to answer some key questions as to the purpose of this underground complex. It could not possibly be a fortification, or any kind of defensive mechanism. Neither could it be a complicated system of damming up or controlling the flow of the river Aude. If they had been the foundations of a mill, there would be traces of its existence. If they were used for storage purposes, then their location seemed odd – they are too close to the river Aude and they would not be built underground, but above ground. Again, we see the light, but cannot reach it. Every two steps forwards seems to incorporate one step back.

Another possibility of learning what used to be there is to test the memory of the local farmers, who have their grounds along the borders of the estate. Thus, we learn that at the end of the 19th century, a certain Mathieu Ilepe discovered a section of the complex, whilst clearing his field with a

ploughshare, stumbling across several vestiges on the surface. It seems that he was intrigued by his discovery and looked carefully at the stones, some of which had a series of ancient words, beautifully engraved, upon them. He collected the stones which had been broken by his plough and took them to a teacher, who then gave them to the Archaeological Commission of Narbonne.

It was left to Mr. Jean Guiraud to analyse these and provide his expertise. He began by stating the obvious, which was that the stone had been broken. It had been a marble plate, engraved with a funerary text, a dedication to the gods known s the Lares. Certain parts were missing, including the complete name of the "owner"; only "asis" was visible. A date was also visible: 118. Apart from the slab, there were also other remains, some pottery and a beautiful bronze ornament, which ended up as a gift in the Museum of Narbonne. Among the shards of pottery, Jean Guiraud also observed the anachronistic presence of several Lares, whose origins predated the votive marble by two or three centuries. There were also pieces of an oil-burner, decorated with the head of the goddess Tanit. These were apparently also dated to ca. 300 BC.

Who were the Lares? Lares were Roman household gods, who protected the family, property and farms – though they could also guard entire cities. Shrines to the Lares were found in people's homes and often at crossroads. They connected the past to the present and were traditionally associated with the hearth. They were originally spirits of the fields, and with the development of agricultural knowledge, they became associated with plots of farmland. Later, they became connected with buried flesh – and it seems that it is in that aspect that they were incorporated here: ancestral spirits, protecting the family, but also the dead, who were buried there.

The Romans viewed death as the defilement of the person, and this defilement should be removed with the performance of certain rites. Specifically this required the sacrifice of a sow to the goddess Ceres, a sacred meal eaten at the burial site, and a ritual cleansing of the home of the departed. From this evolved the modern customs of holding a "wake", which includes a meal, and sending flowers to the home of the deceased. What about Tanit? Known as Astarte to the Phoenicians, she is the symbol of love, fertility and fecundity. It is often claimed that her temples were the settings for "sacred prostitution" performed "for her benefit".

Using the observations of J. Giraud and M. Ilepe, there can be little doubt that the statues were discovered where the underground cavity was located. Furthermore, we need to realise that these are statues... as in statues of similar form or description to those which had been uncovered by Mgr. de Rébé and subsequently reburied on the spot where they were found.

The farmer, Ilepe, stated that his plough had done more damage than merely break the marble slab. He had smashed it into a kind of small drain or "passage", going towards the river Aude. However, there was no water inside the drain. This statement is remarkable because of the depth of this gutter and the proximity of the Aude.

A surgeon ventured along the river Aude at the beginning of the 20th century, in order to make careful observations. Professor Philippe-Henri Lonet arrived from the Bordeaux region. He came because he devoted his leisure time to the photography of historical subjects and various curiosities. He also tried to uncover the extent of the underground complex in that particular area. Working thoroughly and methodically, he drew up a detailed plan of the entire system. With the assistance of a friend, an architect, he made further discoveries, which supplemented those made earlier by his predecessors. His main focus was on the right bank of the river, where he noticed that older stones had been used in the construction of newer buildings. Furthermore, he felt that stones in the lower walls presented elements of a geometric shape that would date them to the Middle Ages. Fortunately, Lonet took an entire series of photographs, which he treasured. He also found various wells within the area. However, they were all blocked up around 1897, the very year the administrative files of the underground complex of Notre-Dame-de-Marceille disappeared from the civilian administrative records.

At the beginning of the 20th century, "Electricité de France" installed a transformer at the bottom of Notre-Dame-de-Marceille. And this is where the story leaves the pages of history and can be verified on site.

When Jos Bertaulet was peering over the river Aude, to find out whether or not there was anything important or enigmatic to be seen, the only thing he saw were the remains of the disused building that once housed the transformer. He walked down the Sacred Path and instead of crossing the bridge, made a right hand turn, following the river, in the direction of the building. Once there, the tower greets you, but you make your way past it, along the left-hand side. Today, two metal plates rest on the ground. In 2001, there was still duct tape, left behind by the rescue operation that the police had mounted here to "rescue" Keith Prince – an event, which had happened in 1995. But it was 1990 when Bertaulet made the discovery: that underneath all the grass – no metal plates back then – were two openings. One, he would eventually learn, was a straight drop into an underground cavity – a man-made vault. Although many people believe Keith Prince fell through this opening, thus injuring himself, it is not true. Both Keith and Clive Prince had discovered the "proper entrance", a bit further on, in front. There, a V-shaped series of steps descends into a low passageway, running just underneath the surface. The walls are rough, but the ceiling is smooth: nice, smooth marble slabs.

100

After approximately five metres, there is a sheer drop. Once again, it was not here that the accident befell Keith Prince. Using a rope, you can then descend into the man-made cavern. When you look upwards, you will see the opening forming the sheer drop; if open, it would act as a skylight, but more likely, it is the access through which whatever was deposited here, was lowered. It was here, in the rubble left behind after

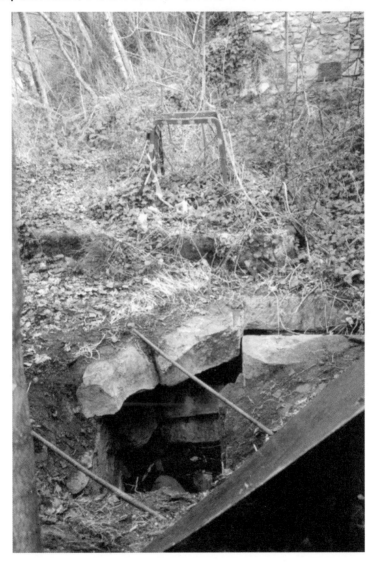

Entrance to the subterranean vault, status in 1997, after Keith Prince's accident inside.

Jos Bertaulet and friend had cleared it all away, that Keith Prince twisted his ankle and thought he might have broken his leg. After some time, Clive Prince decided to run for help – finding it from the Lazarist priests next to the church – who claimed total ignorance of the existence of the underground structure. They sent for the police, an ambulance and the cave rescue team – one or all of which then informed the local newspaper. What eventually transpired, was that Keith Prince's injuries were minimal (a strained calf muscle) but that the cat was now definitely out of the bag: the local newspaper had reported on the discovery.

It followed a series of publications on the subject. 1991 saw the publication of Jos Bertaulet's book, only available in Dutch, but which inspired a writer to incorporate the find into a children's novel. Philip Coppens worked for this publisher in 1993 and was introduced to the subject, with the specific request to see whether there might be any foreign interest in this book. Although in the end, there was none in the book in its present state, there was interest in the discovery itself. Writing in a small publication on the subject in 1994, Clive Prince made contact with Philip Coppens in 1995, resulting in a meeting in July of that year – barely a few weeks after he and his brother had been responsible for the publicity, and only a few weeks before Jos Bertaulet's death. The episode was then written down in their book, The Templar Revelation. In the following years, further research was carried out, both by Philip Coppens in trying to establish the framework of Bertaulet's discovery, and from early 1997 onwards by André Douzet, on everything else, adding to or substantiating observations made by Bertaulet a decade earlier.

By 1995, Jos Bertaulet had sold 500 copies of his book from a total print run of 1,000. Yet, in that year, during Philip Coppens' first visit to the site, with Jos Bertaulet, it seemed like divine providence that they should come cross a young couple standing in front of the porch of Notre-Dame-de-Marceille, with his book in their hands. At first, when Philip pointed this out, Bertaulet thought he was joking. But when Philip then insisted that they should go over and meet the couple, Bertaulet discovered these two had indeed come to Notre-Dame-de-Marceille to see the underground structure, but had not entered it.

During that four-year period, there had also been an attempt to make a television documentary on the site. Raw footage was filmed just days before tremendous floods hit the Aude region. They transformed the access route to the complex, washed away the bridge (now restored again) and, coincidentally, also washed away most of Rennes-les-Bains cemetery.

So what had Bertaulet discovered? A low-level passageway, just under the surface led to the first vault. Descent from the tunnel to the vault is best made by rope, but can be done without such aide if you are an

experienced climber. Opposite the entrance, in the right-hand bottom corner, is a small opening to a second room – there is also an opening at the very top of that wall. Originally, the entrance was often wet and sometimes hazardous to get through. Few people have entered the tunnel, even fewer have descended into the first vault – only a handful of people have entered the second vault, but these do not include Jos Bertaulet.

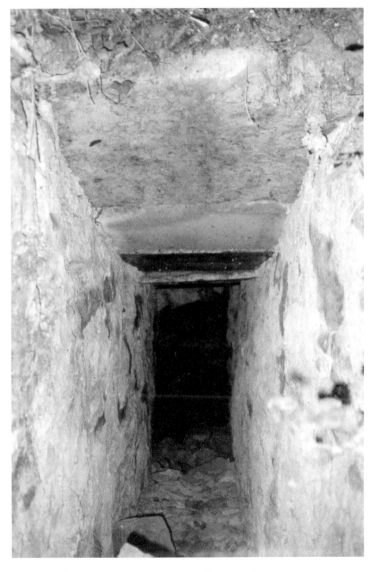

The corridor leading to the main parts of the vault

103

The only feature in the second vault is a small opening in the wall, which seems to be an inlet and/or outlet for water, so that the complex could be flooded.

It is clear that the tunnel is a later addition. Probably, the skylight opening was deemed to be too dangerous and impractical – or too visible. The area around the tunnel opening indicates that a house was built over it. Literally inches from its front door, is the opening descending to the tunnel, leading to the vault, which itself sits in front of the building – i.e. anyone entering the building has already passed by the skylight opening. Equally obvious is that whoever built the structure on top knew of the existence of the tunnel – or might even have created it. Nevertheless, the structure shielding the tunnel entrance does not seem to be part of the transformer building. It seems to have been levelled when construction for the transformer building began. Only the lowest courses of masonry survive; they appear to have been built during the 19th century, they are impossible to date precisely.

That the tunnel is another addition is made clear at its end, where the connection with the masonry of vault reveals it was not part of the original design; the opening of the tunnel is also offset from the centre of the vault.

The two vault themselves are made with exceptionally solid material. They are in a style, which does not indicate whether they are medieval or from more ancient times. Bertaulet did send photographs of the location to a professor in Belgium, who replied that, based on his analysis of the photographs, the masonry could date from Roman times, and that the entire structure could have been a Roman vault, used to hoard treasure or some other material. More recently, some researchers have argued for a medieval dating of the structure, but, it seems, the only evidence they use is the disbelief that it would be that old, although why this should be so is not mentioned. Others, including the local school principal, have argued that it might be Visigothic.

But it is now equally clear to every visitor that when the transformer on top of this structure was built, the engineers knew of its existence. Evidence for this is the electric wiring, which runs along and throughout the structure, in an attempt to "earth" the transformer building on top: conclusive evidence – proof – that in the early 20th century, the construction was known. But, it has to be said, that although it was known, once again it was quickly removed from the public eye. After all, would anyone dare to enter a vault where massive electric wires are inches away from your body? Some will say yes, but most will say no.

Bertaulet observed that from the transformer, electronic pylons ran up the hill, over a distance of approximately 130 metres, towards the church. Construction of the transformer and pylons occurred around 1923-4

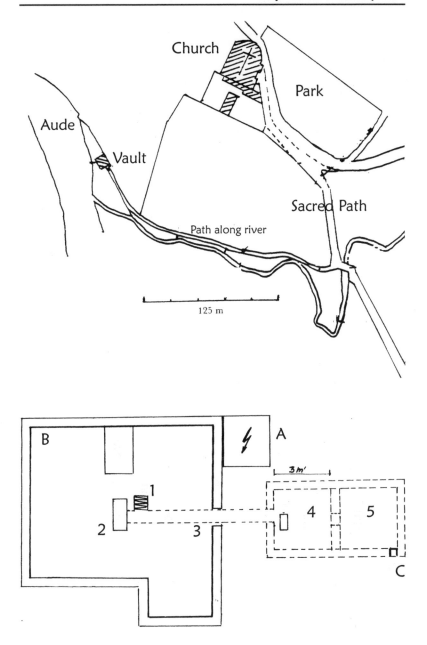

A: electricity cabin; B: building on top of entrance; C: vault
1: entrance to vault; 2: blocked passage; 3: corridor; 4: first chamber, with skylight to left of number; 5: second chamber, with passage for water flow in bottom right

105

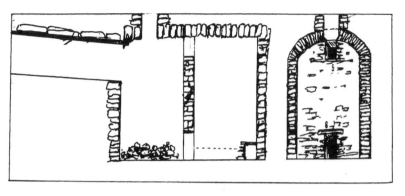

Cross sections (top) and overview of skylight, when blocked by slates, creating an empty space in between.

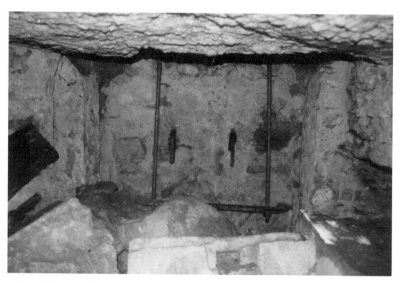

The blocked passage to the right of the entrance to the corridor

and they were operational until 1946, when the electricity distribution was nationalised into E.D.F, Electricité du France. It is clear, therefore, that by 1923, whatever was present in the vault had to be removed. To some extent, anything that was present in the underground complex had to be removed – if anything was still present. 1923 postdated the death of Saunière, who had died in 1917.

So an electric transformer sits on top of what one professor tentatively identified as a Roman vault. The professor – and observations on site – have shown that the entire vault could be flooded. Previously, we listed the observations as to how the underground complex was apparently able to be flooded if the Aude rose high above its normal level. But according to Bertaulet, talking to the locals around 1990, the route of the river next to the vault had been vastly different until a few years earlier. Before the river was dredged, a small, man-made island stood in the middle of the river. Apparently, the water could be regulated, using a basic, but effective system, resulting in a choice as to whether or not the vaults were to be flooded. Of course, the question is whether this was merely able to flood these vaults – or whether the entire underground network could be flooded – for, as we shall see later, there is every indication that the complex is larger than just these two vaults.

This observation has led to the possibility that the two vaults might be a water tank. In some interpretations this is to store water during droughts, in others to flood "something", though what and how is never explained. When the vault made headlines in the local newspapers, some local amateur archaeologists became interested in it. Philip Coppens in particular had some hopes that they might uncover the history and purpose behind the construction, but it was soon made clear that this would not be the case. In the end, they concluded that the entire infrastructure had been created to help in the pumping of water from the Aude up the hill to Notre-Dame-de-Marceille. The reservoir would thus act as a "pump", to somehow provide enough force so that water would be pushed up the hill in the pipe. Possible in theory, but in practice, questionable.

Note that a maximum height of seven metres of water could be created within the vault. The top of the vault is approximately fifty metres below the top of the hill, to where water would be pumped. Therefore, the static thrust of seven metres of standing water (maximum) would have to move water up the hill, about 60 metres higher (the opening was obviously required to be at the bottom of the vault, to use the "weight of the water"). Although an electrical or even a manual pump might achieve this, it is clear that the vault itself would never produce enough static thrust for this task. Knowing this was a silly suggestion, in some circles the conclusions have been re-interpreted to make the vault modern,

107

specifically built as a pump at the time of the electric transformer, to enable water to be raised from the river to Notre-Dame-de-Marceille by means of this pump. Very logical, but completely at odds with the evidence. There is so much wrong with this latter interpretation that on-site inspection of the structure is the best evidence against it. However, let us argue it in some detail.

For one, it would result in massive amounts of electric wiring running through a vault filled with water, which would then be pumped up via an electric engine to the top of the hill. I believe that electricity still carries a current... So unless that law of physics does not apply in Notre-Dame-de-Marceille, the entire installation would blow itself to smithereens in a matter of seconds – electrocuting everyone in the vicinity. And there is no evidence of any such explosions, in case someone would wish to argue that conclusion.

Still, we should not be too harsh. It is known that there was a pump here, placed at the time when the transformer was installed, and that this pump did indeed push water up the hill. But that pump is not the two vaults. The two vaults had a different origin, and a different purpose.

Theophilus Lasserre, priest and friend of Boudet, in his work on Notre-Dame-de-Marceille, specifies: "an underground tank built at the bottom of the hill of Marceille receives water from the river that is naturally filtered. On the higher gallery, the suction pipe exists, activated by a small machine of four horse power, bringing water to the externally built water-tank between two buttresses of the church." Lasserre describes formally what he sees: "a gallery above ground" from which a pipe runs, driven by a "small machine". It might seem as if he is taking about the underground vaults, but this is not so. His pump is above ground. Furthermore, Lasserre does not describe the extravaganza of the two vaults – something he would definitely have done, when you note how detailed all his other observations are. Therefore, it is clear that something else was located nearby, and that this was indeed a water-pump. But – guess what – there is no evidence to be found for its existence. No documents, drawings, etc. No wonder it was a miraculous fountain for these Lazarists: they had water, but it seems it was coming from nowhere. But it is clear that by the late 19th century, the pretence could not be maintained. Lasserre noted the existence of a pipe, running up the hill – but where exactly or how, is not known.

The EDF transformer was activated around 1927, though little is known of its function. It is known to have fed a pumping station (no doubt the second incarnation of the four horse powered system that was in use), but surely it must have done more than just that? The electrical installation is now gone, but the building itself remains. Although it is now derelict, it was only abandoned, it was never destroyed. This is possibly the only

non-mysterious aspect of Notre-Dame-de-Marceille! But at the same time, it is clear that the structure masked the underground vault successfully, for between 1927 and 1990, no-one seems to have been aware of the underground vault – or had access to it.

A clear pattern emerges. Originally, there was the underground vault, accessible via the skylight. At some point, a tunnel was built that allowed for easier access – and specifically secret access. A house or shed was built near the vault, with steps leading through a tunnel, into the tunnel. Later, in 1927, the house was destroyed, to make way for the transformer building. During its construction, the underground vault was wired in order to earth the structure, guaranteeing that no-one will gain access to it or use it. Some decades later, Notre-Dame-de-Marceille received its electrical supply via an new route, and the transformer fell into disuse.

But that is not all. During the building works for the transformer, it is clear that the workmen were aware of both the tunnel and the vault. When entering the passageway, it turns left. But when we look on the right, there is clear evidence of a start of another tunnel, going right. However, less than a metre inside, a huge block of steel-enforced cement has been sunk in, anchored from the surface. In short, this block of cement cuts off what seems to be another tunnel, going right. It suggests that the block of cement purposely blocked off this part of the complex… and it suggests that behind that wall, lies the rest of the underground complex.

Several researchers on site have made that observation, sometimes independent of each other. The very first people who saw the vault noted it, but as the two vaults were then the major discovery, they often forgot to mention the possibility of this "blocked off tunnel" veering to the right. Again, the best indication of its presence is an on-site inspection.

Where does this leave us? Bertaulet's discovery proved that there is substance to all the rumours. Bertaulet formed a nexus between two periods. Since 1991, people have tried to find further historical evidence for Bertaulet's discovery, which was then largely absent. As we have uncovered, this absence of evidence was intentional: the authorities have been very careful to make sure that there was no evidence available, at least until the 19th century, and most likely until the early part of the 20th century. But in the centuries before Bertaulet, it is clear that similar finds, if not the underground vaults themselves, had been uncovered occasionally, and that at all times, the Church made sure that these discoveries were carefully obscured. Why?

Chapter 13
Remember St Vincent de Paul

Right in front of the church of Notre-Dame-de-Marceille, on the opposite side of the road, sits a pleasure garden, offering along its walls excellent views over the surrounding landscape. Close to the church rises a statue of St Vincent de Paul. The saint's presence seems to be quite straightforward. The Lazarists are installed next to the church – and have been there for many decades, witness their presence at the dedication ceremony of Saunière's church in Rennes-le-Château.

Vincent de Paul was born on 24th August 1581, in the parish of Pouy, in the diocese of Dax. He was ordained priest in 1600, when he moved to Toulouse to take a course in theology there. He attained the degree of "bachelor" in 1604. But then trouble came his way. "The following year, Vincent was obliged to go to Marseilles to receive a legacy which had been left to him by one of his friends, who had died in this city. Ready to go back to Toulouse, he accepted the offer to return by boat, to Narbonne; but the ship was taken by pirates. De Paul was captured, taken to Tunis, and initially sold to a fisherman, then to a doctor, after whose death he was sold to a renegade, a native of Nice in Provence. Vincent was exposed to all kinds of tests during his captivity; but despite promises, threats or ill treatment, nothing shook his faith." Finally, he succeeded in re-converting his master and his wife, who enabled his return to France, on a small boat, on 28th June 1607.

That is the official story of Vincent's trials and tribulations. But once back home, strange things appear to befall him. Barely back in Western Europe, Vincent de Paul goes to Rome... to have an audience with the Pope, even before informing friends or family of his return. He is then sent back to France – Paris – where he is received by King Henry IV, and in 1610, obtains the position of chaplain of Marguerite de Valois. He thus becomes acquainted with the Cardinal de Bérulle, who engineers his appointment to the envied function of tutor of the children of count P. E. de Gondi. Later, the Count encouraged the king to make Vincent the General Chaplain of Galères.

In the following years, Vincent's ambitions grew and grew, including the creation of a new order of priests. In 1632, the regular canons of Saint-Victor ceded the priory of Saint-Lazare to him. The place became the focal point of his congregation and its members became known as "Lazarists".

In 1660, the congregation comprised nearly thirty houses, four hundred priests and one hundred brothers. In 1660, the houses become independent from each other, beginning in France, then spreading to in

Statue of Vincent de Paul in the park/garden of Notre-Dame-de-Marceille

Ireland, Scotland and Poland, and even as far as Madagascar. De Paul died on 27th September 1660 and was canonised in the 18th century. The work of his Seminarists was taken up by one of his most attentive disciples, Jean-Jaques Olier (born in 1608) and attached to the Parisian church of St Sulpice in 1642. It is this church that features profoundly in the mythology of Rennes-le-Château. As we have noted, this is the church that Saunière allegedly visited, for an explanation of the discovery inside his own church. Mgr Billard is alleged to have funded his trip to Paris. Alas, there is no evidence for this trip or his visit to St Sulpice.

This brief summary of Vincent de Paul's life seems to be quite straightforward, but at the same time already highlights a period of great mystery: his time in captivity, as a slave, in Arabia. Bizarre however is the fact that upon his return from slavery, he is immediately propelled to the highest ranks of the Church and State, with audiences with the pope and the king, both making sure that afterwards de Paul wants for nothing.

The above account of de Paul's life was taken from J. B. Pélagaud (written in 1861, with the authorisation of the Pope), where the events are different from other accepted accounts. First, a small detail: the vessel leaving Marseilles is taken by "pirates", not Arabs as most biographies have it. Furthermore, he learns alchemy from one of his compatriots, not from a Moslem alchemist, as most authors allege. Thirdly, although his "alchemist master" has given up his Christian faith, Vincent is asked to sing for one of his concubines the psalm "Super flumina Babylonys" (on the rivers of Babylon) and "Salve, Regina". It is stated that the concubine was so affected by this that she converted back to Christianity.

After ten months of hardship, Vincent de Paul is finally on his voyage back home, where he is reconciled with the vice-legate of Avignon. But

111

rather than flee, he and his former master, who is originally from Nice, sail back together – and it seems that both meet the vice-legate. His families and friends would have to wait several more weeks – and some of them months – before they were informed of the fact that their son and friend was still alive. Allowing people to continue in the belief that you are dead, is definitely not something "saintly", one would think.

But that is not all: he then goes to Rome, where even more mystery befalls him. "From Avignon, Vincent de Paul went to Rome, where he visited the tomb of the Apostles. Towards the end of 1608, he left Italy, charged, by the cardinal of Ossat, to speak to King Henry IV on a very significant matter, which he did not want to write down in a letter. Having arrived in France, Vincent went to see Henry IV." All of this is mysterious business. Why do the Vatican and the Holy Father do not have more "qualified" messengers than this man, who is already apparently ill-fated when he has to travel even short distances, and who is to all intents and purposes, a "novice clergyman". What is it about him that he is entrusted with information that is so sensitive that the Vatican decides it cannot be written down?

This is an incredible sequence of events. We are sure no-one would believe any part of it – and it seems that later in life, de Paul shared the same belief. If it was all true and there was nothing more to it than that, it makes a joke of the affairs of state: a young priest sightseeing in Rome, who should know better and who really ought to go and see his worried family, is asked by a Cardinal to go back to France, to inform the French king of a most important secret.

Putting that information to one side, the story echoes a similar account, also involving Rome, a priest and the French king. In that same century, there was a letter that passed between the brothers Fouquet, of which there were three: one (Louis) was a priest residing in Rome, one (François) was archbishop of Narbonne (the original destination of de Paul's ship), but the third (Nicolas) was the main advisor to the French king, Louis XIV.

The correspondence between the brothers details information which Louis has picked up in Rome, and which he will mention to his brother once he is in France, once they meet face to face. The information is of such grave importance that it is labelled as the "greatest secret", and it is said that it could potentially rock heads of state – for which read King Louis XIV. Intriguingly, Fouquet states that he got this information from a painter, Nicolas Poussin, a French master working mostly in Rome. It is Poussin whose painting of the Shepherds of Arcadia was promoted by many "experts" on Bérenger Saunière as being the fount of all knowledge in the mystery of Rennes-le-Château. And it is this painting which is intimately linked with Saunière's alleged visit to Paris and St Sulpice.

Although there is no evidence to prove that he made such a visit, we should begin to wonder whether those claiming that he did, might either have proof that they do not want to or cannot divulge, or whether they have created this lie, to point certain researchers in a certain direction. But for the moment, let us stay with Vincent de Paul. Some other questions need to be asked. Was de Paul really abducted, or was that story concocted later? Was he perhaps on a secret mission? Sent perhaps to meet someone with specific knowledge? Perhaps this former inhabitant from Nice, well-versed in alchemy, somehow possessed specific knowledge, which de Paul had to extract from him? Did he consequently receive that information and was he asked to go immediately to the Vatican, to inform the Church officials of this new information? Was he perhaps told consequently that he should also give that information to the French king?

This scenario would seem quite logical. It would explain why de Paul was entrusted with it: he already knew the secret information, so it would be natural for him to present it to the French king. De Paul would not be told anything he did not already know. In fact, he would be ideally suited to brief these officials himself, as he had the most knowledge about the situation and was thus best placed to answer any questions.

There are more strange things about Vincent de Paul. It is known that for the rest of his life, he would try to recover all correspondence which mentioned his "abduction". After his return, he had to inform his patron, de Comet, of his safe return. De Comet had paid for his education and was therefore greatly intrigued by de Paul. News of his likely death must have upset him; de Paul could furthermore not merely announce his safe return; de Comet would need to be given some details of precisely what had happened to him. So he wrote the story in several letters, and sent them to de Comet. But, as mentioned, late in life, de Paul went on a crusade to try and recover these letters. He made a special effort to do so between 1658 and 1660, and once he had retrieved them, he burnt them. Of course, he must have known he would never succeed in finding and destroying all letters, but he did succeed in destroying many. Why would he do this? Some possibilities have been put forward, but none withstand careful scrutiny. It seems obvious that they contained certain details de Paul did not want to see become public knowledge – or remain in the public domain.

On another level, however, the story of the life of de Paul is reminiscent of another story: that of Bérenger Saunière. In both instances, we have young priests, fresh from the seminary, who seem to have been "taken" into confidence and prepared for special missions. And it seems that in both instances, they are well looked after – though in the case of Saunière, it is clear that his fortunes did change once the new bishop, Mgr de

Beauséjour, arrived on the scene.

But that is not all: those who brought Saunière to fame, who promoted Poussin, also promoted Vincent de Paul: this so-called "Priory of Sion", whoever they are. Let us state here that Pierre Plantard, the man who was the visible representative of this organisation - whether it existed or not – stated that de Paul had not been abducted, but that instead he had spent his time in Notre-Dame-de-Marceille, where he had been trained in alchemy! He stated that it was not "Marseilles", at the mouth of the river Rhone, but was in truth "Marceille", near Limoux.

It is a strange allegation to make, and when it was made, in the early 1980s, there seemed nothing special about Notre-Dame-de-Marceille. It would only be from 1993 onwards that the "Bertaulet circle" began to pay specific attention to this statement of Plantard & Co. Let us state how remarkable these words are: Plantard made this apparently ridiculous statement at a time when no-one was interested in Notre-Dame-de-Marceille, or even particularly in Vincent de Paul. But slowly, it is clear that all pieces of the puzzle – all the evidence – begins to show that Plantard might not necessarily have been right in the de Paul allegation, but that there is definitely a link between Rennes-le-Château and Notre-Dame-de-Marceille; the best evidence for this we will present shortly. For the moment, let us agree that it is highly likely that Plantard was involved with the secret manipulators – or their descendants – of Saunière himself.

Plantard and co. stated that Vincent de Paul had studied with "Jean the Alchemist", who had taught him in the castle of Barbarie, in Nièvre. Philippe de Chérisey, one of Plantard's "company", labelled this castle the "Occult Bastion of France". Of course, Plantard never presented any proof of these allegations – in fairness, no-one ever actually asked. It is true that King Louis XIV did dismantle the castle in June 1659, the specific order coming from Cardinal Mazarin.

But it is clear that Plantard did bring out two intriguing aspects: he did not accept the official story of Vincent de Paul's abduction; he links this abduction with his subject, the mystery of Rennes-le-Château, as Jean the Alchemist is linked with the "mystery of the Priory of Sion"; finally, he links all this with Notre-Dame-de-Marceille, at a time when there was no interest in Notre-Dame-de-Marceille by any person connected with the Rennes-le-Château or Priory of Sion mystery; at a time when Notre-Dame-de-Marceille seemed to be nothing more than a normal church, without any mystery whatsoever.

Both de Paul and the Fouquet family became embroiled in the affairs of the French state in the 1640s and 1660s – to some extent, they directed them. The history is complex, but what is important to note is that this is the period of the Compagnie du St Sacrement, the predecessor of the

The Shepherds of Arcadia, by the French artist Nicolas Poussin

AA, the organisations that maintained "the secret". Both de Paul and the Fouquet family were directly involved with this organisation.

If we were to draw a timeline of "the secret", then it might start with de Paul and his mission between the Vatican and the French king, which itself originates from his secret mission which was officially labelled as an "abduction by pirates". Echoes of this secret were later picked up in Rome, and became known to the French painter Nicolas Poussin.

At that time, after the death of her husband, Anne of Austria, mother of Louis XIV and regent of France, became a supporter of Vincent de Paul, both in his Lazarist mission and the Compagnie de St Sacrement. She gave de Paul 18,000 pounds-worth of jewellery to help him.

But, as always, there are opponents. In the opposition camp were Mazarin and Louis XIV himself, who in 1665 comes down against both his mother Anne of Austria and the Compagnie, disbanding the society officially. It seems that part of this campaign includes Mazarin's orders to destroy the Barbarie castle, because of its connections with Vincent de Paul, according to Plantard.

One person caught up in all this turmoil was the bishop of Alet, Mgr. Nicolas Pavillon (1597-1677). Pavillon and de Paul were close friends, with de Paul becoming the spiritual "father" of Pavillon. In 1627, Pavillon entered the priesthood, where for the next ten years, he would become

the collaborator and confidant of Vincent. On 22nd August 1639, Pavillon was crowned bishop, but he maintained his close relationships not only with de Paul, but also with Olier, the future founder of St Sulpice. In essence, de Paul, Pavillon and Olier formed a triad, the centre of the Compagnie du Saint Sacrement, vying for the attention of the royal family, which they had, with the Queen Regent.

Pavillon was, of course, also a faithful follower of the Archbishop of Narbonne: Claude de Rébé, the man who came to inspect the statuettes discovered in Notre-Dame-de-Marceille, and who reburied these later. Notre-Dame-de-Marceille belonged to Alet (Pavillon), and Alet in its turn belonged to Narbonne (de Rébé).

Furthermore, it is Lasserre, Boudet's friend, who implied that Nicolas Pavillon was "pushed" towards becoming bishop of Alet by Vincent de Paul, in order to take care of the welfare of Notre-Dame-de-Marceille. Alas, Lasserre does not quote his source for this information, but it is clear that this allegation is most interesting – and hence, perhaps, the reason why it is not given.

A simple conclusion– taking Plantard's information into the equation – could therefore be that de Paul had uncovered a secret, perhaps revolving around alchemy, in Notre-Dame-de-Marceille, about which he told the Vatican, as well as the French King. Later, he then made sure the site was under the personal care of one of his most trusted aides, Pavillon. Pavillon at some point either told his superior, de Rébé, or de Rébé found out via some other route. Later, one of the Fouquet brothers would sit in the same seat as de Rébé before – Archbishop of Narbonne.

If we add Poussin to this equation, the soup becomes even more intriguing: Poussin resided in Rome, but was recalled to France by the intermediary of Cardinal Richelieu, to submit himself to the French court. He arrived in Paris on 17th December 1640. He was received by King Louis XIII, who seemed to make life for the painter as pleasant as possible. But he did not adapt to the atmosphere and seemed to spend much time travelling about France. On 2nd November 1642, he returned to Rome.

A month later, on 4th December Richelieu died and on 14th May 1643, King Louis XIII himself died. Anne of Austria became Queen Regent. Sublet, Poussin's protector, was immediately disgraced. Poussin himself would never return to France. But it seems that his return to Rome was in haste: it seems he knew that the death of Richelieu and perhaps even that of the king were imminent, and that his stay in Paris beyond their demise might turn out to be very dangerous. Still, back in Rome, he became linked with Cardinal Giulio Rospigliosi, who would be elected Pope Clement IX in 1667, two years after Poussin's death.

Rospigliosi seems to have valued the paintings of Poussin. After all, Poussin

116

was a famous artist. The subjects he was asked to paint were of a highly symbolic nature, often detailing allegorical or religious scenes. Rospigliosi ordered a total of seven paintings from Poussin. The best-known of these paintings is the previously mentioned "The Shepherds of Arcadia", currently in the Louvre Museum in Paris. Others are the "The Dance of the Human Life" (1638 and 1640), "Time and Truth" (1638-1640), "The Holy Family", "Zenobius helped by the Shepherds" (1657 and 1660), "The Vision of St Francoise" (1656-1658) and especially the "Refuge during the Escape from Egypt" (1638-1640). This painting has been lost and only a sketch remains in which the Holy Family is depicted as fleeing from Egypt on the back of an elephant. It also seems to contain a monument identical to the tomb in "The Shepherds of Arcadia" – and the now dismantled reproduction of that tomb at Pontils, near Arques. Art historian Erwin Panofsky, in Meaning of the Visual Arts, states that the phrase Et In Arcadia Ego, again promoted by Plantard & Co., was a particular favourite of Rospigliosi. It seems therefore that he was the one who ordered Poussin to incorporate it in his painting of "The Shepherds of Arcadia". Although the phrase might not be the actual key to the secret as many have alleged, it is clear that Rospigliosi was the man who must have told Poussin about "the secret".

Rospigliosi was also very close to the former queen of Sweden, Christina. She had ruled her country between 1640 and 1654, but had forsaken her throne for her Catholic faith. She lived in exile in Rome, where she met Rospigliosi. But there is another interesting detail: the enigmatic letter about the great secret between the Fouquet brothers was written in April 1656; the following fall, Christina of Sweden was welcomed to Paris... by Nicolas Fouquet. Coincidence?

Obvious question: did Poussin somehow encode specific knowledge into these paintings, on instructions or with the help of Rospligiosi? If so, it is clear that the secret would not be the presence of a pentagram, as Baigent, Leigh and Lincoln have argued in their book. As far as we are aware, geometry is not a secret – though it might appear to be so to many – and no-one has ever made a fortune out of it; why de Beauséjour would object to geometry takes both this argument and the entire line of geometric reasoning to an absurd level.

The letter between the two Fouquet brothers is dated 17th April 1656, and written by Louis to Nicolas, superintendent of Finances of France. Some have argued that it was not written in 1656, but in 1640. However, it must date from either 1655 or 1656, as this was the period when Louis Fouquet resided in Rome. Born in 1633, he was sent to Rome to monitor the movements of Cardinal de Retz, a man who some years previously had tried to remove Louis XIV from the French throne. The fear was that de Retz would try to prepare another attack against the throne

from Rome. It is clear, therefore, that Louis Fouquet tried to find out all kinds of information, in the hope of being able to discover what de Retz was doing. Information never comes neatly packaged, and often you find things that are more intriguing than what you were actually looking for...

The letter reads: "Poussin and I discussed certain things which I shall be able to explain to you in detail. Things which will give you, through M. Poussin, advantages which even kings would have great trouble in drawing from him..."

Therefore it seems that fourteen years after his departure from France, when he had been called in for questioning by the king, Poussin was still aware of something he is apparently willing to share with Nicolas Fouquet, Louis XIV's right-hand man. The year was 1656, or almost half a decade after 1608, when de Paul carried a similar message to Henry IV; twelve years before Rospligiosi will become Pope.

What was Poussin's secret? According to some – believe it or not – it had to do with garden design! Yes indeed, lest no-one believe us: Anthony Blunt, who, apart from being remembered as a secret agent, was also an expert on Poussin. When he was asked about this letter, "Blunt merely admitted that the letter 'had never been properly understood by art historians', but that he thought it might be about 'a commission for ornaments for Fouquet's garden.'" No wonder intelligence agents have never had any reputation for telling the truth! And let's hope they are liars, rather than as stupid as they would otherwise be!

In 1661, Fouquet was removed from his office and thrown in prison, where he would remain until his death, twenty years later. Upon his death, his two servants were also locked up, so that "they will have no communication with anyone either by speech or by writing", because they might have knowledge of the "majority of the important matters of which M. Fouquet was cognisant."

At the time of his arrest, all correspondence by Fouquet himself was seized on the orders of King Louis XIV – who then checked everything in personal. When we know that the allegation was malpractice of his office, it is extremely unlikely that the king would, in such a case, take such a personal interest.

What was that all about? Some have speculated that this "secret" had to do with information regarding the real father of Louis XIV, who is widely believed to have been "engendered" by someone other than King Louis XIII – his official father. The miraculous birth was echoed by his name: Louis-Dieudonné: given by God.

Speculation on the reason for his imprisonment has also tackled the possibility that Fouquet had redirected a great deal of funds from the king towards his own purse, and that eventually the king decided that

118

Nicolas Fouquet

he had tolerated it long enough, and removed him from office. Possible, but it is not borne out by the evidence.

Louis Fouquet is very precise: Poussin is in possession of information which cannot revolve around the parenthood of Louis XIV, even though it might explain why he went back to France just before Louis XIII died. Fouquet writes: "advantages which even kings would have great trouble in drawing from him";
Poussin had information, a secret, which he could not share, even with the king, even if he asked him to. But it seems that Poussin was willing to share it with Fouquet. This is bizarre.

Perhaps this is what had happened before: perhaps Poussin knew something years earlier, by 1640, when the French king invited him to his court, in an attempt to "extract" that knowledge from the painter. But Poussin did not want to, and made sure that although he could not blatantly disobey the king, he could make it clear that he was not going to talk. He either feared Anne of Austria, or instead he used the occasion of Richelieu's and the king's death to leave France for happier places. But back in Rome, Poussin was talking again, and it seems the Fouquets knew, and received an invitation to "learn" the secret. This at a time when a Cardinal and later Pope might also have known the secret, and was at the very least working with Poussin. Queen Christina of Sweden seems to have been involved in this group also. So were the Compagnie du Saint Sacrement, whose main centre of operation was Paris – and who after the entire episode, continued to hold "the secret", and passed it on to the "AA", who seemed to have been the prime movers behind Bérenger Saunière.

Question: was this the same secret known to de Paul, who had spoken about it to Henry IV? Henry IV made a late marriage to Marie de Medici, fathering Louis XIII with her. Henry IV was then assassinated, which might mean that anything he might have passed on to his son, could never be accomplished because of the sudden death. We might even wonder whether the assassination had anything to do with "the secret". Louis XIII married Anne of Austria, and "fathered" Louis XIV, who came down against his own mother's preference for the Lazarists and the Compagnie – a Compagnie in which the entire Fouquet family was involved.

So, finally, is this what happened: de Paul informed Henry IV of a secret,

but this was lost by the French kings. However, it was learnt that in Rome, or one man in Rome, Poussin, still knew. Poussin was invited to tell Henry's son, Louis XIII, but he declined. However, he was willing to share this information with Fouquet, and it seems Fouquet made sure the Compagnie knew as well. The role of Anne of Austria is ambivalent: although she seems to have seen this "secret" as not directly undermining the position of the French crown, others, particularly Mazarin, decided that it did and he persuaded Louis XIV of his case, coming down against those who knew – the Compagnie, Fouquet, etc. The Compagnie went underground, to become the AA. Meanwhile, in Rome, Poussin was still alive, though not for long: by 1666, he was dead, possibly having passed his information on to others. In France, Fouquet "knew" but Louis XIV made sure that anyone who might know, would never be able to tell anyone else. The information was not lost, but now definitely secret itself. The protection of the secret had now become a secret itself…

Logical, but whether or not it is correct is difficult to prove. After all, we are dealing with a "secret" – and thus the only thing we can say for certain is that all the enigmas are neatly "explained" by this "logical sequence" of events. We can even wonder whether it was this secret that cost the life of Henry IV. He was, after all, assassinated by a "lone madman" – something which in this modern age has become a euphemism for conspiracy.

On that note, Poussin had his personal proverb: "I did not neglect anything!" Fine, but not very revealing. Nevertheless, this eye for detail meant that he was able to negotiate a successful path between the various parties. Fouquet on the other hand, did not: perhaps his all-too-hasty accumulation of wealth might have made the king suspicious. No-one knew where it came from, but it had to be coming from somewhere. Either it came out of their pockets, or had Fouquet been told the secret, and was "the secret" the source of his wealth? Perhaps this was an early parallel of how "the secret" might have lead to Saunière's wealth, before his quick accumulation of riches made his superior suspicious?

If Louis XIV believed Fouquet knew, even though Poussin had not "bothered" to tell his grandfather, it is clear that the king would have been furious – if only because Fouquet had obviously not shared it with him.

Although we cannot go into too much detail here, some points from the court case against Fouquet are intriguing, if only because of Louis XIV's attempts to meddle with the jury. At one point, he demanded that Fouquet would not only be found guilty, but would be sentenced to death. The jury felt this was absurd and did not agree. In the end, there was more interference, the king in essence "accepting" that life imprisonment was "harsh enough". On the one hand there was a jury

who heard the evidence and felt that Fouquet had done nothing wrong (acquittal was definitely on the cards), on the other hand there was Louis XIV, who wanted the death penalty. Why? And although it might be a personal vendetta between two men, the declaration that anyone who communicated with prisoner Fouquet would receive the death penalty goes far beyond common sense and logic.

What did Fouquet know? The actions of brother number three, François, might provide the answer. Brother number three makes sure he can acquire Notre-Dame-de-Marceille, and once acquired, makes sure that the bond with the Lazarists, i.e. Vincent de Paul, is tied. Fouquet did not have a reputation for being generous, so why he went to the trouble of buying Notre-Dame-de-Marceille only to give it to the Lazarists, is out of character for him. Was it his task to make sure that "the secret" was kept safe? And note that de Paul is believed to have sent Pavillon to Alet, to keep an eye on Notre-Dame-de-Marceille.

That, however, is not everything. It might have escaped our attention, but it seems that although Poussin himself was not a priest, the "secret" itself seems to have been entrusted mainly to priests– if not only. We have two of the Fouquet brothers, who were priests – only Nicolas was not a priest. Vincent de Paul, the cardinals, Richelieu, Rospigliosi, all were priests. So were Olier and Pavillon... so had been de Rébé... and in the centuries to come, so was Berenger Saunière. And Boudet, and Lasserre, who would all talk about either Notre-Dame-de-Marceille, Pavillon or would have wealth at their disposal beyond their observable means.

To make matters even more bizarre: when, three centuries after the fateful events that befell Fouquet, Noel Corbu became the owner of Bérenger Saunière's estates – which he bought from Marie Denarnaud, the priest's only heiress – he requested a grant from the Church for his children's education. It was one Mgr. Roncalli, the apostolic nuncio, who intervened personally with the bishop of Carcassonne – Billard's and de Beauséjour's successor – to give him the grant. Roncalli would later become Pope John XXIII, and herald tremendous changes in the Vatican. Was this a coincidence... or was it design?

After the Second World War, it is claimed that the Bishopric of Carcassonne approached Marie Denarnaud and tried to buy the property. But Marie turned a deaf ear. According to a diocesan priest, Mazières, the Church then instigated a complex plan to recover the estate. The Bishopric commissioned a priest in the diocese, Abbé Gau to contact Noel Corbu, one of Marie's distant cousins. At that time, Corbu was in prison for certain wartime activities. If he agreed to persuade Marie to give the property to the Church, he would be released. He agreed, but when he was free, he double-crossed his liberators by persuading Marie to sell

121

him the property.

Corbu sent his two children to religious schools in Carcassonne – but soon the fees proved too expensive. It is highly unlikely that anyone else would even think of it, but Corbu wrote to the Vatican and asked the Holy See to cover the expenses of educating his offspring. The Carcassonne Bishopric learnt of this with astonishment when the apostolic nuncio, Mgr Angello Roncalli turned up to make enquiries about Corbu's letter. Not very pleased to say the least, Carcassonne gave a negative answer, which was relayed to the Vatican. Even so, the astounded Bishopric learnt a short time afterwards that the Vatican had in fact accepted Corbu's request.

What sort of pressure, if any, was Corbu able to exert on the Vatican? Perhaps we shall never know, because he died a few years later in a tragic car accident. According to researcher Jean-Luc Chaumeil, this might not have been so accidental. Chaumeil is one of France's most respected researchers, who has had access to a number of secret documents, because of his personal involvement in the French intelligence services

Intriguingly, one researcher, Daniel Pogatel, had stated that the negotiation that occurred with the help of Roncalli involved the recovery of certain documents that had been in Saunière's possession, in exchange for the grant, specifically photographs, notes and documents on the sanctuary of Notre-Dame-de-Marceille. An intriguing allegation and the reason why it never become better known is no doubt because until recently, no-one ever took any notice of Notre-Dame-de-Marceille, and hence was unable to see the importance of these allegations. But as far as proof that Saunière and Notre-Dame-de-Marceille are connected is concerned, this testimony would convince any jury.

But the coincidence does not stop here. Although France in the 20th century no longer had kings, it did have presidents, and Charles de Gaulle was one of the most famous. It was he who nominated Roncalli as the best candidate for the papal office... Once again, is this a coincidence? Or design?

Coincidence can be stretched only so far, until it breaks. Several enigmas have been strung together to form one encompassing framework, which, we hope, is logical and explains the series. Sceptics might argue that each individual piece can be explained differently. But as we have seen, their "explanation" – such as the idea that Poussin might be willing to grant a garden design to Fouquet but possibly not to the king – never stands up when placed into its proper context. History is a sequence of events and although discussion on individual events can often be explained away, most such explanations fail to withstand the test of logic when held against the whole sequence. No man is an island; neither is an event.

Chapter 14
The Templar Connection

The Templars seem to stand in the shadows of many mysteries. Their presence in Notre-Dame-de-Marceille should not therefore come as a surprise. The Templars had a presence in the region, specifically at Campagne-sur-Aude. It was in this house that King Philip IV tried to place a spy inside the organisation, to find out whether or not the order had certain significant deposits in their possession. Rumour has it that nothing was learned from this exercise. Nevertheless, Niort ceded their properties at Le Bézu to the Templars and it seems the king was unable to find out why.

Unfortunately, Mazières remains silent as to where he heard the rumour that the Templars in the area possessed vast underground complexes. These Templars from the Razès and Roussillon were working closely together, to create "a vast state, independent of the South. They never gave up on this project, at least not the Templars of the Roussillon and Aragon. This extraordinarily secret company was, by the 12th century, organised from the Commandery of Mas-Déu."

One of the backbones of the Templars' wealth was their vast financial empire. They used "Arab gold" as a currency, rather than the normal currency in circulation. In the Razès, not far from Rennes-le-Château, a "gold ingot, of almost twenty kilogrammes, made of an amalgam of small Arab coins" was discovered. Another gold ingot, this time weighing in at approximately fifty kilogrammes, was found on the grounds of Le Bézu. Such currency was also found around Limoux, uncovered by farmers during their everyday chores (Martial Tuisset, Mr. Buthard, J-C Founelod) or during road works (Paul Lorrandet, N and J Quauloume), for example when roadworks were being carried out next to the church of Notre-Dame-de-Marceille.

Furthermore, many documents about and from the Templars would curiously disappear in the area of the Aude. These included the Temple archives, especially one significant document and another regarding a place called "Reddas". Unfortunately this is the only detail that remains of this affair: "a copy of this document going back to before the Great Revolution, belonging to the archives of the Knights of Malta, was still in the possession of the old priest of Campagne-sur-Aude, Antoine Beaux in 1943. It disappeared at the time of the German occupation, as well as other manuscripts and an old chalice known as the "chalice of Malta". The inhabitants remember it very well, as well as documents they refer to as 'the parchments'."

One tradition has it that after 1285, with the ascension of Philip IV to the

throne of France, the Templars felt that their position had become insecure. The Order wondered whether their houses "are believed to shelter confidential documents, the crown jewels or monetary reserves". Persistent rumours could be heard that the Templars came into the Razès to exploit a Visigothic treasure. One place that was mentioned was Blanchefort, near Rennes-le-Château. The rumour might have originated from the knowledge that one Grand Master of the Templars, Bertrand de Blancfort, or Blancafort (1156-1169) might have been related to the family of the Razès.

Another tradition stated that the Templars came from afar to seek gold and money, and carried it away from there. They dispersed, in a secretive manner, the monetary reserves, which they felt were no longer safe in their houses. They entrusted these reserves to the Roussillon families, who were well-disposed towards "Majorca". After 1307, these deposits were not apparently recovered. This might explain the presence of these treasures in or near the Bézu valley. A large part of the treasure was given to the Templars of Campagne-sur-Aude, who placed it in an underground location and a "cache".

Mazières also makes vague reference as to how this treasure would be located under the church or close to the church, without specifying clearly where exactly it is in the Campagne-sur-Aude area. He merely refers to a network and how this was known to, if not operated by, the Templars of Campagne-sur-Aude, without any further comments.

The Templars might have known that they were heading into troublesome times. It would have been clear that the first to fall would be the commanderies and the larger houses. These would be searched from top to bottom and any secret deposits would quickly be discovered. It seems logical to assume that the Templars would distribute their possessions, and place them elsewhere. Although they might not be able to benefit from them in the future, they would be damned if their potential future oppressors would benefit from it!

This would explain why the sergeants of the king never found anything of interest when they raided their properties. And it is clear that the king was only interested in their properties, for he seldom if ever arrested Templars who were travelling – hardly any of these were arrested, and they seem to have disappeared into a black hole.

It is known that the Order had a property next to the church and the buildings of Notre-Dame-de-Marceille, from where it was possible to reach part of the "underground complex". This complex does correspond to the description, which Mazières says existed in Campagne-sur-Aude. As there is no such evidence to be found in Campagne-sur-Aude, the question should be whether perhaps the events Mazières describes occurred elsewhere.

124

The archives in Malta mention that the Templar occupation of the site of Notre-Dame-de-Marceille existed by 1269. The "Décimaire", listing all important Templar possessions, includes property in Notre-Dame-de-Marceille, belonging to the Order of Douzens. They possessed 114 items out of a total of 272 – i.e. just under half of Notre-Dame-de-Marceille. The other 158 were distributed between the Hospital of Magrie, the archbishop of Narbonne and the monks of Prouille. This means that the Templars possessed the majority of the estate. The majority of these pieces of land were located on what would later become known as the "Garden of the Olive Trees". This means that the Templar properties were indeed next to the church and the ancient cemetery.

Architects working from old prints have argued that in the 13th century, the church of Notre-Dame-de-Marceille looked like a fortified building, a keep. Gilles Semenou notes: "Did it not, in 1562, at the time of the wars of religion, shelter the Catholic garrison of Limoux?" This architecture is typical of the soldier monks of the Temple. This specifically defensive architecture was preserved until the 16th century, until the church was refitted with a nave and began to take on its modern look.

Before then, the sanctuary was a self-sustaining unit, with a cistern collecting rain water – and an apparent underground complex that would have been of great benefit in times of siege – if only perhaps to escape from the location without the enemy knowing it. The "miraculous well" would also provide drinking water, if the skies did not provide it through the cistern. These are specific "Templar designs", which are also found in the Templar church of Montsaunès. It suggests the church was built on a "Templar church template". That is not all: it is clear that the Templars had a specific dedication to Black Madonnas. In the Aude region, the only Black Madonna of note is that of Notre-Dame-de-Marceille.

Alet, to where Pavillon was sent as bishop, is another location with Templar connections. Jean Simon, who is always careful not to include non-verifiable assertions, presents the discoveries at Alet as a Templar message. One very old house of the old borough has several strange signs on it. Several inscriptions are able to give dates such as 1642, 1652 and 1643. These cryptic dates, if that is what they are, would therefore be from the 17th century, long after the Templars' demise. The connection with the Templars is made because similar engravings, sculptures and signs are found in the church of the Commandery of Montsaunès, 150 kilometres away. But the same signs are also partially engraved in the leaves on the gate of the church of Notre-Dame-de-Marceille – suggesting yet another Templar connection. As it is known that the Templars owned land in the immediate vicinity of the church, it should not be surprising to find such signs in or on the church.

But Templars were not around in the 17th century. Jean Simon believes

that a strange and old inscription that was found in Palau in the Roussillon reads: "in another form we continue." He wonders, therefore, whether the Knight Templars, in "another form", did live on into the 17th century – and were responsible for some of these enigmatic references. Perhaps they were the ones involved in the enigmatic affairs of Poussin et al.? Jean Simon states that not only were the messages found in Palau, but they were also in Alet, where a whole line of coded signs was found, and in Planès as well, where no-one was ever able to offer a satisfactory explanation for the signs. Simon believes there is a geographical bond between Planès, Montsaunès and Alet. In his opinion, it was part of an old Templar network that was part of the pilgrimage towards Santiago de Compostella. These coded messages might have been read by those who had the key to understand them – that pilgrimage would mask another pilgrimage. It seems that this system might have been re-activated temporarily in the 17th century. Pavillon's presence in Alet could be a part of this. But although Simon does include Pavillon, Notre-Dame-de-Marceille does not appear in his analysis. Then again, it should be noted that until very recently, no-one ever thought there was any mystery surrounding this basilica.

Notre-Dame-de-Marceille was not the only location in the vicinity with Templar connections. Down the road, there were Templar tombs in the nave of an important abbey by the name of Saint Hilaire. In Limoux, we find the Order receiving "an equivalent compensation of ground not far from the Aude", on behalf of a royal justice, even though it is not known why, who or where this strange royal "compensation" came from.

In the archives of Limoux, there are documents detailing the Templar properties in the area: "262 rural tenures, including 16 in Marceille, 30 in Condamine de Cougain, 24 in Rossignol, 32 in Salles-sur-Aude and the remainder in the neighbourhood." This relates to the properties owned by the Commandery of Douzens. But on enquiring about the deeds for the land of Notre-Dame-de-Marceille, these documents are untraceable. Worse, they are officially qualified as "missing pages"! Were they missing because maybe they identified too many details concerning these Templar grounds "on ground not far from the Aude"? Intriguingly, the documents are noted as having disappeared at the beginning of the 17th century, when the strange activity begins to appear around Notre-Dame-de-Marceille.

We should not forget that Pope Clement V, formerly Bertrand de Goth, had a specific interest in the treasure of the Commandery of Montsaunès. He declared that the three Templars knights stationed there were not to be arrested; they had to take care of the treasure. The treasure was said to have been objects of great spiritual and monetary value, including major relics such as those of John the Baptist, as well as the horn of a

unicorn! Clement apparent obtained this exceptional condition with the assent of King Philip the Fair. Both had engineered the demise of the Templars, but it is clear that Clement and the King seemed to be interested in specific property of the Templars, and kept it for themselves.

But that is not all. The area of St Bertrand de Comminges, Barbazan and Montsaunès was the region from where the vicar César Brudinou originated, also in the 17th century. He was a penitent of the same order which would safeguard the Black Madonna of Notre-Dame-de-Marceille during the French Revolution the following century. It suggests that though several centuries apart, the events of the 14th century which saw the demise of the Templars, but the curious reprieve of Templars at St Bertrand de Comminges, and the events of the late 18th century, were somehow related. It suggests that whatever might have been at Notre-Dame-de-Marceille, might have been known to the Templars – and was somehow preserved over the generations.

Chapter 15
Full circle

It seems that the people involved in the mystery of Rennes-le-Château and those involved in Notre-Dame-de-Marceille converge. But despite the presence of all the main players, only one of them has never been linked with Notre-Dame-de-Marceille: François Bérenger Saunière. This in itself is remarkable: that somehow Saunière would not know about something that all of his friends and correspondents were interested and involved in. It seems here that absence of Saunière in this enigma is most likely to be evidence of his presence – but at a discreet level. After all, we know that Saunière's secret life was, well, secret. Despite many books on the subject, only in recent years have we been able to uncover components of that secret life. We know, therefore, that Saunière was a master at keeping things secret, and his involvement in Notre-Dame-de-Marceille does not seem to be any different.

Henri Boudet appears to have been a key link between Saunière and Notre-Dame-de-Marceille. He makes specific reference to the place in his 1886 book, on the origins of the Celtic language. It is a curious book that has become impossible to avoid in the enigma of Rennes-le-Château. It is Boudet who is one of the few authors, if not the only one, to insist formally on the etymology of "Marsilla" and its different "puns", a work taken up again by Theophile Lasserre. Lasserre was priest of Alet-les-Bains, but also co-owner of Notre-Dame-de-Marceille, which he had inherited through his family.

In his "History of the pilgrimage of Notre-Dame-de-Marceille", Lasserre quotes Boudet so frequently that one ends up wondering whether Boudet did not hold more information on Notre-Dame-de-Marceille than did Lasserre, however specialist he might have been on the matter.

Lasserre's study, however, does not concentrate solely on Notre-Dame-de-Marceille. He also pays attention to Alet and Rennes-les-Bains. Referring specifically to the latter town suggests that there might have been a close connection between Lasserre and Boudet, who was the village priest there. On page 11, Lasserre mentions "works" performed by the first bishop of Narbonne, Sergius (589), who sent his priests "to engrave Greek crosses that can still be seen on the standing stones, which form part of the stone circle of Rennes-les-Bains. Opposite the pagan temple which was converted into a church and at the top of the western mountain, we saw carvings on the standing stone of the 'Cap de l'Homme', i.e. a beautiful head of the Saviour looking down at the valley, dominating the Celtic monuments." And: "Close to the villarium or hamlet of St Salvaire, near Alet, there is a local tradition that a standing

stone can be found there, surmounted by an iron cross, which is the object of particular veneration."

Such references are devoid of any relevance to Notre-Dame-de-Marceille. But when the topic of a cromlech in Rennes-les-Bains is mentioned, it is clear that the only person with such a fascination was Boudet – and thus that Lasserre was at least familiar with Boudet's work, if not the author himself. Still, Lasserre is not wrong: at one point in its history, the Church decided not to destroy pagan sites any more, but to Christianise them instead; this fits perfectly within the approach that the bishop of Narbonne ordered his men to take in the region.

Still, there are curious references also. Page 16: "There is a question of the relics of the body of Mary Magdalene, and their protection against an unknown danger in 710." On page 17, he leaves the topic of Notre-Dame-de-Marceille completely and focuses instead on Rennes-le-Château. He discusses a little known episode. "Thus undergoing the rage of the Muslims, the knowledge of this rich deposit and its whereabouts was carried into exile by faithful ministers, or went with them to the grave. The Moorish invasions would last for more than one century. The historian Marca states that to avoid persecution, the archbishops of Narbonne were obliged to take refuge in the stronghold of Redda – believed to be the modern Rennes-le-Château. This city was the capital of the Razès for more than a century, when the invasions continued. Times changed for the better when Charlemagne conquered the Moors in the 8th century."

According to Lasserre, the treasure mentioned above is that of Notre-Dame-de-Marceille. Whether or not this is true, what is clear, is that Lasserre, and hence possibly Boudet, and hence possibly Saunière, seem to have believed it was true. And for the first time, we have a possible explanation for the anomalous income of Berenger Saunière.

Lasserre's book often refers to knowledge he has derived from Boudet. He writes, on page 279, about the hiding place of the Notre Dame statue, which Boudet apparently studied purely out of religious interest. But it is clear that Boudet was the only one who had information on the whereabouts of the Madonna, at a time when no-one else possessed such information. This is curious for several reasons, as Boudet's main interest apparently was in the two Rennes, not Notre-Dame-de-Marceille. Furthermore, Boudet did not write about this information publicly, so when Lasserre refers to Boudet as the source of his information, it is clear that the two priests spoke together, and that Boudet confided a lot of personal knowledge on Notre-Dame-de-Marceille to Lasserre.

But that is not all. There are other people from Saunière's inner circle that we stumble across. The dedication of the book is made by E. Cros, whose name is also linked with Bérenger Saunière, for his study on the tombstone of Marie de Nègre d'Hautpoul. Another intriguing reference

is that on page 40, Lasserre mentions Pavillon, the bishop of Alet. On the same page, Lasserre discusses the intervention of Archbishop François Fouquet in 1660. This is most enlightening from the perspective that Lasserre and Boudet were definitely aware of the interventions of Fouquet in the matter of Notre-Dame-de-Marceille.

Lasserre was also aware, as written on page 41, of the peculiar funeral events of the Lord of Hautpoul: "In 1647, Antoine d'Hautpoul, lord of Rennes, a native of the diocese of Alet, was wounded by a blow of a musket to the left jaw, in the battle of Holzen, in the Alsace. He ordered that his body should be buried in the church de Cordeliers in Limoux, and his heart preserved in Notre-Dame-de-Marceille. He also bequeathed 2000 pounds to the church for two masses per week, in perpetuity." This family was, of course, extremely closely connected with Rennes-le-Château. Family documents from the Hautpoul family, dating from that era, are believed to be at the core of the "secret of Rennes-le-Château". Another person at the core of that mystery was Pierre de Voisins. On page 5, we read: "Pierre de Voisins, one of his generals, had Limoux and the county of Razès as his prerogative. He raised its ancient capital, the city of Rennes with its castle, where the Hautpoul, through various alliances, became the Lords of, until 1793."

Another reference, on page 85, concerns Billard, who is said to have intervened in the "Paroles Prophétiques" relating to Notre-Dame-de-Marceille and its porch, on 10th September 1881. Lasserre is also aware of Mgr. de Rébé and his interventions. From pages 85 to 88, we read that based on a document of 10th June 1641, he is aware of interventions of the archbishop on the site of Notre-Dame-de-Marceille. It is an intervention which then disappeared without leaving any traces – quite similar to the enigma of Rennes-le-Château.

On page 59, Lasserre mentions, and quotes, a strange Mrs. Vie, who was entrusted with some testimonies concerning the circumstances as to how the Black Madonna was put into safety. Was Mrs. Vie any relation of Jean Vie, another character in the Rennes-le-Château mystery?

Almost the whole of page 79 is taken up by the Countess de Chambord. We learn that she, together with her husband Henry V, were interested in Notre-Dame-de-Marceille – despite being in exile abroad. Her specific interest seems to have been a gift of a Byzantine icon "engraved or corrugated in silver and gold, filled with precious stones", which represented the Virgin with the Child on her arm. The episode seems to have its origins in events, which Lasserre felt occurred in the 15th century. This statue, set in glass, was placed above the niche of the Black Madonna. On this page, we also learn that the Countess de Chambord would have been informed of the status and the activities going on in the church through her doctor, Dr. Carrière. Carrière was also a cousin of Lasserre.

Note however that the Countess was not only interested in Notre-Dame-de-Marceille, it is known she donated money to Saunière for the vital repairs to his church. At the very least, we now have a clear line of communication: the Countess, her doctor, Lasserre, Boudet, and thus Saunière. Although there may be other routes of communication between these various parties, we have now found at least one – which is more than most other researchers have been able to find. And the reason why this connection has been discovered, is because no-one else has looked into the missing piece of the puzzle: Notre-Dame-de-Marceille, which seems to act as a glue that binds all players in the mystery together.

It is clear that Lasserre, priest of Alet, knew many things that had either already been lost but were somehow still known to him alone – or other things, which seem to have been forgotten since. But what is clear is that Lasserre created the single source for information on Notre-Dame-de-Marceille of his time. And it is clear that the circle of people he worked with on the project, are identical to the people that were around Saunière. Although most of the connections are largely unknown, in themselves, they should not be that surprising: you would expect the various village priests to share information and gossip and help each other out with their individual projects.

But although that might seem "logical" now, what is not logical is that all of this interest converges on Notre-Dame-de-Marceille, which we know is a place of mystery, intrigue and an underground complex in which our actors, and their predecessors, were extremely interested. And the little cabal of the 17th century that did not stop talking about "a secret", also tried to make sure that they came into the possession of Notre-Dame-de-Marceille. Although the link between "the secret" and Notre-Dame-de-Marceille might not be a straightforward connection between just those two elements, it is clear that they do fit within the same, perhaps larger, framework.

But that is not all. Fouquet was not the only one who tried to own Notre-Dame-de-Marceille. Billard did so as well. At the time when Saunière started on his road to wealth, Billard was involved in trying to acquire Notre-Dame-de-Marceille. And here, it seems, matters finally begin to make sense.

Ownership of Notre-Dame-de-Marceille had always been a hotly debated topic. Pope Clement VI gave possession to the "College of Narbonne", on 14th March 1344. The "college" was created by Bernard des Farges in Paris, in 1317. It meant that the archbishop of Narbonne, the owner and superior of the college, also possessed Notre-Dame-de-Marceille. The situation remained so for three centuries, until 18th April 1660, when the "consuls" abandoned all their rights to Notre-Dame-de-Marceille. On 8th December 1660, the College of Narbonne, also annulled their

ownership of Marceille. This meant that François Fouquet, archbishop of Narbonne, and brother of Nicolas Fouquet, became the sole owner of Notre-Dame-de-Marceille, a privilege he was able to maintain for 14 years. It is remarkable how suddenly, in a period of under one year, in 1660 to be specific, everyone involved seems to lose interest in Notre-Dame-de-Marceille, even though some years earlier, de Rébé was extremely interested in the site. It suggests that Fouquet was working behind the scenes, to make sure he alone would be in a position of power on the site.

Fouquet wanted to open a seminary in Notre-Dame-de-Marceille. The year he became bishop, he purchased property at the back of the church. A large hall was constructed, which could house the religious community. Fouquet became so involved in this issue that Vincent de Paul wrote him a letter, urging him to "remain calm", otherwise it would have a "tragic end". It is clear that de Paul was referring to something bigger than merely the opening of a seminary. De Paul was telling Fouquet to act calmly, and not to arouse suspicions. But it seems that either François Fouquet or someone else did arouse some suspicion...

The mysterious letter had been written in 1656, the purchase of Notre-Dame-de-Marceille occurred in 1660. In 1661, King Louis XIV began his campaign to topple Nicolas Fouquet from his position and demand the death penalty – definitely a "tragic end" for the Fouquet family.

Before his death, François Fouquet tried to give the ownership of Notre-Dame-de-Marceille to a Congregation, but he died before he was successful. Nevertheless, his successor did.

At the time of the French Revolution, we know that the statue of the Black Madonna was stolen. But on 20th April 1793, the church was also sold to Martin Andrieu, for 10,000 livres. The sale incorporated the house, the garden, the church minus the statues and paintings, and an "olivette". On 21st February 1795, the Convention of Churches stated that churches and temples could be re-opened – Notre-Dame-de-Marceille was reopened on 8th March. Nevertheless, the Constitution of French Departments from 1790 had concluded that the Aude should no longer report to the archbishopric of Narbonne, but to the bishopric of Carcassonne.

Martin Andrieu sold three-quarters of the church to three other people: Telinge, Durand and one Lasserre. The new bishop of Carcassonne, Mgr. de la Porte, tried to gain ownership of Notre-Dame-de-Marceille in 1804. Unfortunately for him, there was a law which stated that the Church could not appropriate church property that had been sold to civilians. De la Porte therefore resorted to play another game. He believed he still had the right to nominate priests, so he sacked the encumbent, who had been nominated by Andrieu & Co, and nominated his own priest,

Montpellier. He then demanded that money collected during masses was handed over to him. The owners refused and the church was closed. However, the owners realised that a closed church was not a money-making initiative: the church was an important site for pilgrims, which meant that people also paid to stay the night. The church was re-opened and the battle with the bishop continued. The episode was settled on 14th August 1814, when all parties decided to co-operate. The deal was for a period of ten years, but would remain in force until 1893.

The bishop of Carcassonne was not Mgr. Felix-Arsène Billard. He had been ordained priest in 1853 and was appointed bishop of Carcassonne in 1881. He first visited Rennes-le-Château in 1889. In 1891, he was bequeathed, as a private person rather than as bishop, a sum of money of about 1,200,000 Francs from Madame Rose Denise Marguerite Victorine Sabatier, from Coursan. Her family tried to contest the will, but they were unsuccessful in their attempts. This was a substantial amount of money and might indeed have been the anomalous source of income that maintained Saunière – at least in part. In 1893, Billard purchased the church of Notre-Dame-de-Marceille

Notre-Dame-de-Marceille had recently become of interest again. Boudet had mentioned it in his book in 1886. In 1890, a historical study of Notre-Dame-de-Marceille was written in the magazine of the *Société des Arts et des Sciences de Carcassonne*. Boudet had joined the society two years earlier. The writer of the report was another member, Louis Fedié. He acknowledged Firmin Jaffus, who twenty years before had written a booklet on how the treasure of the Temple of Solomon could possibly have been located around Limoux and Carcassonne. Jaffus was also the author of a poem, titled Notre-Dame-de-Marceille.

In 1849, the fields on the opposite side of the church had been purchased, the so-called "Esplanade". On 14th September 1862, the Black Madonna had been crowned by Bishop de la Bouillerie, in the name of Pope Pius IX. The operation of the pilgrimage was entrusted to the Lazarists in 1876.

But then, as mentioned, all hell broke loose. In 1889, before Billard had received his inheritance, he was "suspected" of attempting to influence one of the owners, abbé Lasserre, priest of Alet-les-Bains and, as we noted, friend of Boudet. The battle raged and the two other owners decided that it might cause them serious financial problems. M. Bourrel, a banker, decided to bring in the law. In June 1890, the court concluded that the church had to be sold. Both Bourrel and Andrieu objected to the court's conclusion, but this objection was deemed to be unfounded in February 1892.

The sale of the church occurred on 17th January 1893, at 13hrs 30 min. The buyer was Bourrel, who bought it for 51,050 Francs. The sale caused

133

consternation and Billard was apparently displeased. He ordered that the Black Madonna should be moved to the Church of the Ascension in Limoux. Then, a most bizarre episode occurred which has been written up officially as "what happened next between the bishop and the buyer is not known." On 20th May1893, Bourrel sold the church to Billard, for a sum of 53,879 Francs. But: "Bourrel specifies and delegates Billard to pay: 11,293 Francs to the bishopric of Carcassonne, and the same amount to Andrieu and Lasserre." Although at first it might seem that Bourrel was making a profit on his 51,050 Francs investment, in truth, he has just made a profit of close to 30,000 Francs. Note that Bourrel is furthermore a banker, so he definitely knew what he was doing. And we need to ask why he did it.

It is clear that Billard wanted the property and went to great lengths to obtain it. Either Bourrel was his agent, or perhaps Billard tricked Bourrel. It is clear that Boudet could have influenced Lasserre, who seems to have been remarkably quiet during this entire episode. Although Billard had been told off for trying to pressure him into selling, it is clear that this had paid off: Lasserre went along with whatever was happening.

Whatever the reason, on 2nd July1893, the Black Madonna was the prominent member of a procession through the streets of Limoux, on her way back to the church of Notre-Dame-de-Marceille. It was the period when "mystery" began to invade Saunière's world, mystery which would continue for the rest of his life. Billard was struck down by paralysis in 1898 and died in 1901, at a time when he was in the process of being suspended for "having administered the assets of his diocese in the most irregular fashion and for having contracted staggering debts, which were completely unjustified." It is clear that Billard had not been the best of men, but it is also clear that whatever drove him, he was definitely involved in desperately trying to purchase Notre-Dame-de-Marceille – like François Fouquet had done before him.

Did all of these men act on orders of the Compagnie du Saint Sacrement or their successor, the "A.A.", the hand that moved Saunière? The most likely scenario is yes. Still, they would get away with it – and had it not been for de Beauséjour's enquiry, Saunière would never have come to public notice – and the intriguing details of Notre-Dame-de-Marceille would never have come to the forefront.

Nevertheless, it is clear that on both occasions, they desperately wanted Notre-Dame-de-Marceille – and succeeded on both counts. The question is why…

On 6th October 1912, Pope Pius X decreed that the church was now a basilica, a privilege that is only given to very few churches. It shows the importance of Notre-Dame-de-Marceille. During the dedication ceremony, Bishop Beauvain de Beauséjour was present, as well as the archbishop of

Toulouse and the bishops of Pamiers, Perpignan and Sebaste. Why Notre-Dame-de-Marceille was chosen for this specific privilege is largely unknown. There is nothing in particular that would warrant such treatment. But then, one wonders whether there is something "underneath" that does.

Epilogue

The Lazarists have been guarding the property for the past centuries. When Clive Prince ran up the hill in July 1995, asking them for help as his brother had fallen inside in the vault, they feigned ignorance – an ignorance that was definitely feigned...

In recent years, a fire had struck their house. It had caused damage to their wooden floor. It had to be restored. It was a work which they could not do themselves. They had to call in help. And thus a number of people learned and could prove what we had been thinking all along: underneath the wooden floor was evidence of the underground complex...

Jean-Luc Chaumeil writes that the Bibliothèque Mazarin contains a document listing all the ancient places and their communities. On page 122 and 123, one "Monsieur Roux" has written on Limoux: "Limoux is mentioned for the first time in 854, in a document of Charles le Chauve, in favour of Ana, abbot of St Hilaire, in the diocese of Carcassonne. As a result, certain authors have stated that this city existed in the time of Julius Caesar and that it was defended by a castle named Rhedae." On page 123: "From the side of the mountain, where in the past the city of Rhedae stood, Limoux presents a more picturesque view."

This suggests that the Visigothic capital of Rhedae was not Rennes-le-Château, but Limoux. This, of course, would be perfectly logical. Authors who have placed Rhedae in Rennes-le-Château have never answered the question as to how a town of 30,000 people could have completely disappeared on this mountain-top. In the case of Limoux, such a disappearance would be simple: it would be situated underneath the town itself. It suggests that the most important aspect of the town, the castle, was not the castle of Rennes-le-Château, but instead a castle over-looking Limoux: perhaps Notre-Dame-de-Marceille? After all, we know that it was a station for a Roman garrison before, and the church itself seems to have been a Templar stronghold afterwards. It suggests the site had both a religious and a military purpose.

The 1st June 1967 edition of the "Semaine Religieuse de Carcassonne", the parish newspaper, published an article by one "Mgr. Georges Boyer", Vicar-General. He wrote how the region had become the scene of various treasure hunts involving the mystery of Rennes-le-Château and other places in the area, which had a Visigothic past. He continued: "We affirm without any hesitation that a treasure is hidden in an ancient necropolis, the existence of which is known to the bishopric of Carcassonne, but about which she refuses to unveil the secret." It is an intriguing reference, for at the time

when it was published, there was nothing of this "ancient necropolis" in the public record – no-one had written a book about how Saunière had found a treasure in an ancient necropolis. Boyer, it seems, felt he had to say what the stakes were all about – but no-one picked him up on the reference.

No-one, except one of the people circling around Pierre Plantard: Philippe de Chérisey. That a treasure was hidden in Notre-Dame-de-Marceille was noted by others. But Plantard and Co. made a straightforward connection between Notre-Dame-de-Marceille and Vincent de Paul – and the existence of treasure. De Chérisey stated that Lucius Caesar was one of two sons of consul Agrippa, who had died in Marseille. But it was "Notre Dame de Marseille", near Limoux. His ashes were said to have been deposited in the necropolis of Rennes-les-Bains. According to de Chérisey, he was the "great Roman" referred to by Nostradamus in his Centuries.

When de Beauséjour succeeded Billard in 1902, he asked Saunière to explain his income. Saunière must have known that question would come one day. His reply was that he could not answer it, because it was a "professional secret". Generous sums of money were given to him by great "sinners" – "par des grands pécheurs". Should we perhaps believe that Saunière was joking with de Beauséjour? Was he suggesting it had been given to him by "des grands pêcheurs" – "fishermen"? Was it an oblique reference to his famous pun, "Sot + Pecheur"? Was he really saying that the money was given to him by the A.A.? Possibly. Saunière might not have known whether or not de Beauséjour was a member of the A.A.. Surely, he must have suspected de Beauséjour was not. But no-one can ever be completely certain. So if de Beauséjour "knew", he would get the reference – he would realise the "sinners" were "the fishermen of the AA". But it seems de Beauséjour did not understand – he was not on his side; he went after Saunière with a vengeance. In 1910, de Beauséjour charged him with trafficking of masses, an absurd accusation as Saunière would have had to sell 386,000 masses at 50 centimes to explain the 193,000 gold Francs which he claimed had been donated to him. Saunière appealed to Rome and was successful in 1913. The bishop restated the charges and in 1915, obtained a final verdict, against Saunière. Between 1911 and 1915, Saunière seems to have gone through a financial crisis: many invoices were left unpaid. But in 1916, despite his loss of his position, money was back in abundance. He was planning major works to his estate, including running water to the village, a chapel, swimming pool and a library tower which might measure as high as 70 metres. On 5th January 1917, he placed an order for works for a total of eight million Francs. The work was never carried out; Saunière died on 22nd January 1917. When his will was opened, it was learned that he possessed

137

nothing. All the money belonged to Marie Denarnaud.

It is clear that someone was willing to give Saunière an awful lot of money. It suggests that as a member of the AA, a group with apparently vested interests in the region, Saunière had known important secrets. It suggests that in 1916, he had struck a deal with "someone" to "tell all", for this is suggested by his order of a scale model. However, that is another story...

Based on the presence of a hermit and the description of the vault, certain conclusions by analogy can be drawn from this evidence. The famous pilgrim site of St Patrick's Purgatory at Lough Derg in Co. Donegal (Ireland) has many identical traits of the famous pilgrim site of Notre Dame de Marceille. St Patrick's Purgatory was a pilgrimage site in operation since the middle of the 12th century, when the first written accounts are available. However, it is assumed that the island had a pre-Christian religious importance. It is assumed that the underground "cave" in which the pilgrim descended to encounter angels, demons and have a vision of the afterlife (hence why the cave was known as a purgatory) in origin was a sacred site for the Druids, if not earlier cultures.

The concept of these experiences was to invite people to prepare for death and this concept is known to most traditions, including the megalithic tradition who has left a strong memory in the landscape around Lough Derg. It is furthermore believed that the eyewitness accounts of the original "cave" (now filled in) corresponds with that of a "souterrain". A souterrain is an underground structure consisting of a low passage or a series of them... The passage is generally straight but is sometimes curved and, exceptionally, two adjacent ones lie at different levels. Frequently, the passage opens into one or more chambers. Let us note that this corresponds with the structure of Notre Dame de Marceille. Several souterrains exist from the Iron Age onwards. But we should add that St Patrick's Purgatory is known to have had an access through a door, leading into a gallery, leading into a chamber, but that there was also another mode of access, seldom used but nevertheless described in the literature: this involved the pilgrim being lowered onto a rope into a hole, thus reaching the chamber. It was thus that the Purgatory received its name of "puits" in French: hole. These two modes of access are present in the structure of the vault of Notre Dame de Marceille.

St Patrick's Purgatory is also notorious for its connection with the anchorite tradition. Often, people would go on a pilgrimage, then decide never to return to "normal" life and instead dedicate the rest of their life to live "religiously", often near the pilgrim's destination. This resulted in a large group of "hermits" living on a neighbouring island in Lough Derg. The

parallel with the hermit of Notre Dame de Marceille should be noted, as well as the parallel with the presence of a megalithic sanctuary.

But there are more coincidences. The pilgrim making his way to Lough Derg also had to seek permission from the bishop in whose diocese the Purgatory was located. If this parallel were to extend to Notre Dame de Marceille, this would make the involvement of Billard and the other bishops extremely intriguing. It would also explain the rather bizarre role the Lazarists' presence has played on the site.

Jos Bertaulet himself felt that the site could have been used as a centre of initiation, a "vision quest". The stay in St Patrick's Purgatory was exactly that. The pilgrim would fast for fifteen days before entering the cave. He was then voluntarily locked up inside a cave for one night. Upon his return, he would fast for a further 15 days before returning to the "world of the living". Late in life, Bertaulet became interested in the Visions of Tundale, who share the same tradition as the visions of Purgatory.

In conclusion, we can note that both St Patrick's Purgatory and Notre Dame de Marceille were notorious pilgrim sites. However, St Patrick's Purgatory was a site set apart for an elite who wanted to experience Purgatory. Notre Dame de Marceille was not an elitist site. However, we do need to wonder whether or not there might have been a desire by certain pilgrims to experience Purgatory in France. If such a desire was present, might this explain the presence of the vault, with a relatively modern layout mimicking the traditional layout of a souterrain, or the Purgatory in Ireland? These questions are impossible to prove, but the striking resemblances should make us all wonder.

Bibliography

Archives of Allan Marques de Saves, also published in the annals Maurice Mout in 1755. Toulouse (collection Jonet et Sauche).

Au début était le mégalithe. Notes and notebooks of abbé ANCE and of 'Docteur de POLLA'. Consulted at the home of the inheritors of the latter.

Cahiers d'Etudes Cathares. R. Mazelier. n° 70 to 75 (series II), including 1976 B 1977.

Cathares et catharisme. De l'esprit à la persécution. Lucienne Julien. Dangles, 1990.

Le Trésor des templiers et son royal secret: l'Aether. Chaumeil, Jean-Luc. Paris: Guy Trédaniel Éditeur, 1994.

Comme un Grand feu: Vincent de Paul. Robert P. Malone. Strasbourg, 1995.

Département de l'Aude. Adolphe Joanne. Paris: HACHETTE, 1880.

Dictionnaire de la mythologie. Pierre Grimal. PUF, 1951.

Dictionnaire des Société Secrètes en Occident. Collectif. Grasset, 1971.

Dictionnaire des Symboles. J. Chevalier and A. Gheerbrandt . Seghers, 1969.

Dictionnaire Mytho-Hermétique. A. J. Pernety. 1758.

Elémentaire du castelet de Barbasan. Vicaire César Brudinou. 17th century.

Emma Calvé. La Diva du siècle. J. Contrucci. Albin Michel, 1989.

Essai sur le département de l'Aude, adressé au ministre de l'Intérieur. I. Barante, prefect of the said Department. Printed at Carcassonne by G. Gareng, printer to the Prefecture. 'Brumaire an XI' (1803).

Etat relevé par moi Maître niveleur' toulousain Louis Charles de Pennaud. From archives of M. September, who was the director of the Training College, part of the collection the heirs of Jean-Christin Maillot (et Charles Bunyeux)

Fouquet.... 'POUSSIN' A. Mérot. Milan: Hazan, 1994.

Géographie du Département de l'Aude (fourth edition). Adolphe Joanne. Paris: HACHETTE, 1891.

Histoire du pèlerinage de Notre-Dame-de-Marceille. Abbé J. Th. Lasserre, de Limoux. Limoux: 1891.

Histoire Nationale du Dictionnaire Géographique. Département de l'Aude. MM. Girault, de St Fargeau, Berthomieu, et Tournal fils, de Narbonne. Edition Lacour/Rediviva.

Jules Verne initié et initiateur. Michel Lamy. Payot, 1984.

L'AA de Toulouse. Bégouin. Picard, 1913.

La Synarchie. Jean Saunier. Grasset, 1971.

La Vraie Langue Celtique' Abbé Henri Boudet. Carcassonne: Pomiès, 1886.

L'Aude préhistorique – notice sur les trouvailles faites dans le département de l'Aude et sur ses grottes, dolmens et menhirs. G. Sicard.

Lectures variées sur le Département de l'Aude. A Ditandy. Carcassonne: Imp. F. Pomiès, 1875.

Le livre des superstitions. Eloïse Mozzani. R. Laffont, 1995.

Le secret de la Franc-Maçonnerie. Mgr A.J. Faba. Société de St Augustin, 1883.

Le Secret des Prêtres du Razès. Yves Lierre. Neustrie. 1986.

Les Sociétés Secrètes. Serge Hutin. P.U.F, 1952.

Les sociétés secrètes au rendez-vous de l'Apocalypse. Jean Robin. Trédaniel, 1985.

Les templiers du Bézu. Abbé Mazières.

L'or de Jérusalem. Roger Facon. Montorgueil, 1990.

Matériaux Cryptographiques. B. Allieu et A. Barthélémy. Self published, 1983.

Monsieur d'Alet - Nicolas Pavillon. Gilles Séménou. Carcassonne: Gabelle, 1998.

Notre-Dame-de-Marceille. Limoux. G. Migault – C.M. Gabelle. Carcassonne: 1962.

Notre-Dame-de-Marceille – le sanctuaire et son pèlerinage. Gilles Semenou. Carcassonne: Gabelle, 1992 and 2001.

Relation d'un voyage d'Alet. Claude Lancelot, 1667.

Relation d'un voyage fait à Pamiers et à Alet par deux ecclésiastiques. By the brothers Foreau. Foix: Dubruel, 1669.

Relevé terrier sous Les bâtis de l'Eglises de Notre-Dame-de-Marceille de Limoux. Paulan Curto. 1826.

Rennes le Château. Autopsie d'un Mythe. Jean-Jacques Bedu. Loubatières.

Rennes-le-Château. Le dossier, les Impostures. Gérard de Sède. Laffont, 1988.

Rennes-le-Château et l'énigme de l'or maudit. Jean Markale. Pygmalion, 1989.

Rennes-le-Château. Le trésor de l'abbé Saunière. Vinciane Denis. Marabout, 1996.

Reynaud Levieux. H. Wytenhove. Edisud, 1990.

Templiers des pays d'Oc et du roussillon. Simon Jean. Loubatières, 1998.

Vie de Monsieur Pavillon. Le Fèvre de St-Marc et A de la Chassagne. St Miel, 1738.

Vies des Saints pour tous les jours de l'année. J.B. Pélagaud. Imp. De N.S.P. le pape, 1861.

Vincent de Paul. Abelly Louis. Paris, 1664.

Write for our free catalog of other fascinating books, videos & magazines.

Frontier Sciences Foundation
Postbus 10681
1001 ER Amsterdam
the Netherlands
tel: +31-(0)20-3309148
fax: +31-(0)20-3309150
email : info@fsf.nl

website : www.fsf.nl

Adventures Unlimited
P.O. Box 74
Kempton, Illinois 60946
USA
Tel : 815-253-6390
Fax : 815-253-6300
email :
auphq@frontiernet.net

website :
www.adventuresunlimitedpress.com

THE CANOPUS REVELATION
Stargate of the Gods and the Ark
of Osiris

Philip Coppens

The identification of the constellation Orion
with the Egyptian god Osiris has become
engrained in human consciousness, yet it is
one of the biggest misunderstandings.
Canopus, for Egypt the South polar star, is the
second brightest star in the sky and interplays
with Sirius in such a way that ancient ac-
counts say they control time. Furthermore, Canopus was believed to
allow access to the Afterlife - the domain of Osiris. Canopus was
specifically identified with his Chest, his Ark, in which he was trans-
formed from mere mortal to resurrected supergod. This book radically
reinterprets the most powerful myth of Osiris and Isis in its proper
context, offering full understanding both from historical and cultural
perspectives, and shows the way forward... what did the ancient
Egyptians believe that would happen to the soul?

*216 pages. Paperback. USD $ 17,95 * GBP 11,99 * Euro 20.90.
Code: CANO*

CROP CIRCLES, GODS AND
THEIR SECRETS
Robert J. Boerman

For more than 20 years, all over the world,
mankind has been treated to thousands of
crop circle formations, and until now,
nobody has been able to explain this
phenomenon. In this book, besides a
scientific and historical section, you can
read how the author links two separate
crop circles. They contain an old Hebrew inscription and the so-called
Double Helix, revealing the name of the 'maker', his message, impor-
tant facts and the summary of human history. Once he had achieved
this, he was able to begin cracking the crop circle code.

*159 Pages. Paperback. Euro 15,90 * GBP 8.99 * USD $ 14.00.
Code: CCGS*